1914 Vintage Botany Botanical Illustration Sizes (Floral Ephemera Series 5)
By C. Anders

This book is a work of non-fiction. Images in this book may have been retouched. No part of this book maybe be reproduced, scanned, or printed in any printed or electronic form without permission from the author. Please do not participate or encourage piracy of copyrighted materials in violation of the author's rights.
Purchase only authorized editions.
Copyright © 2019 by C Anders. All rights reserved.

*Fuller page sizes of these images can be found in the book: **1914 Vintage Botany Botanical Full Illustrations (Floral Ephemera Series 6)**

**Inside photos of these book pages can be seen at C. Anders Blog: https://vintageimage.blogspot.com

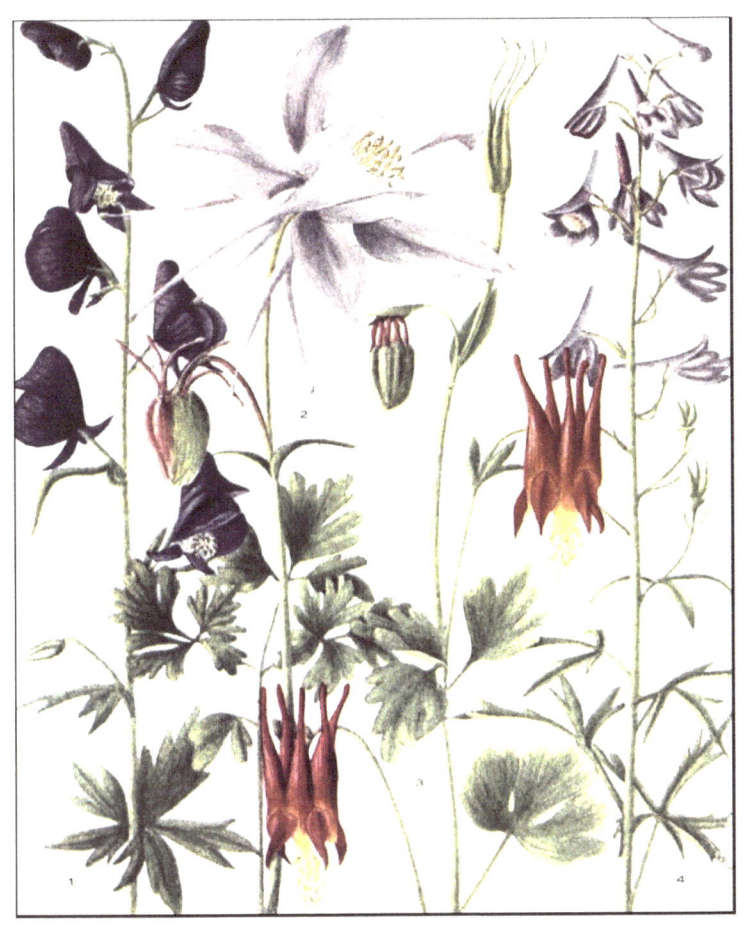
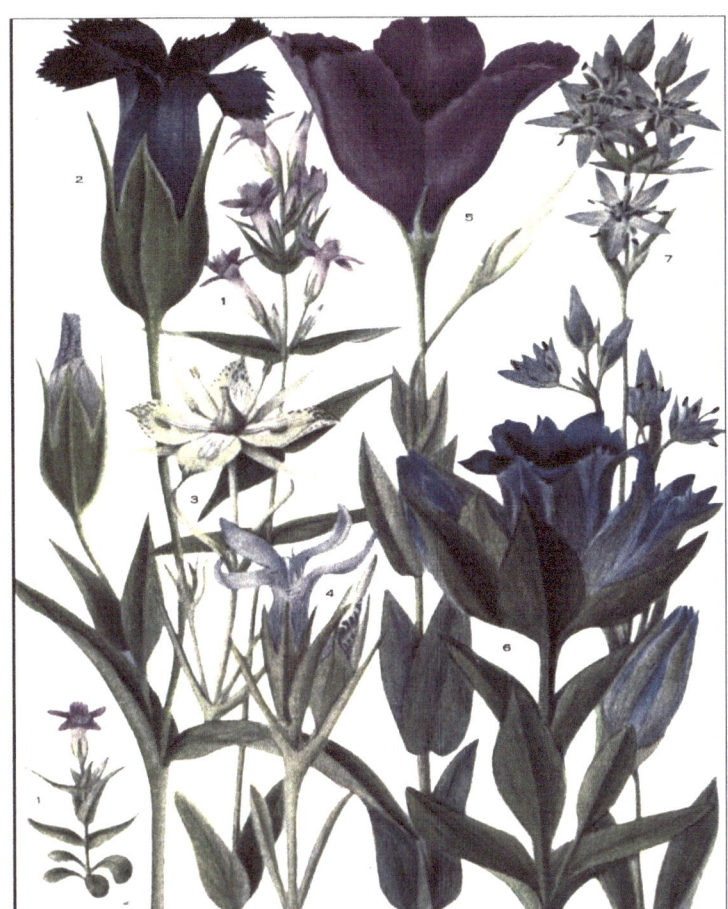
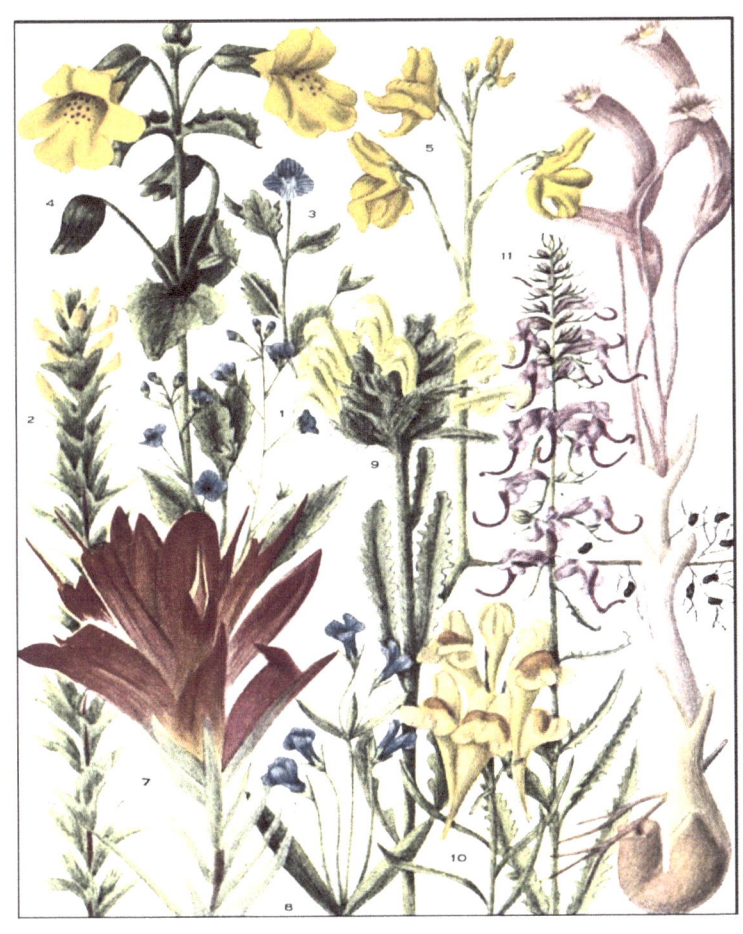
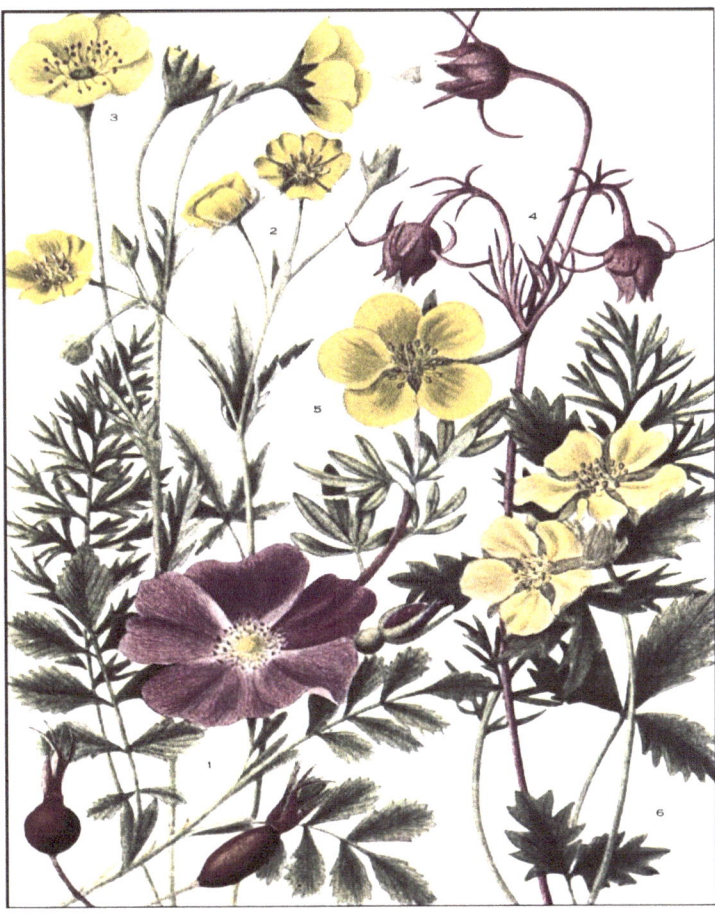

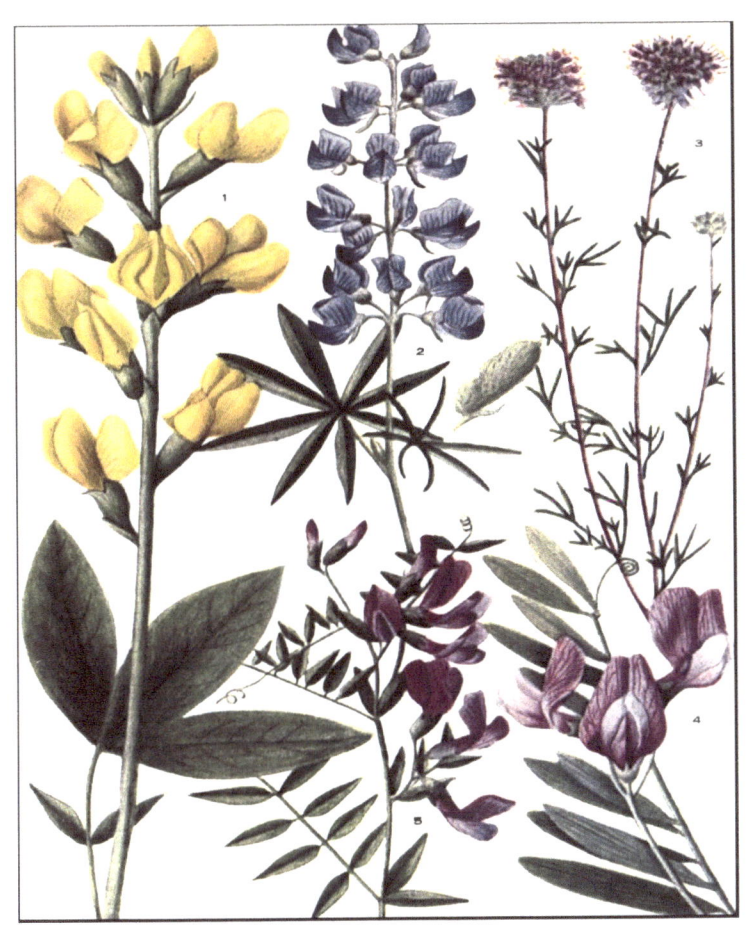
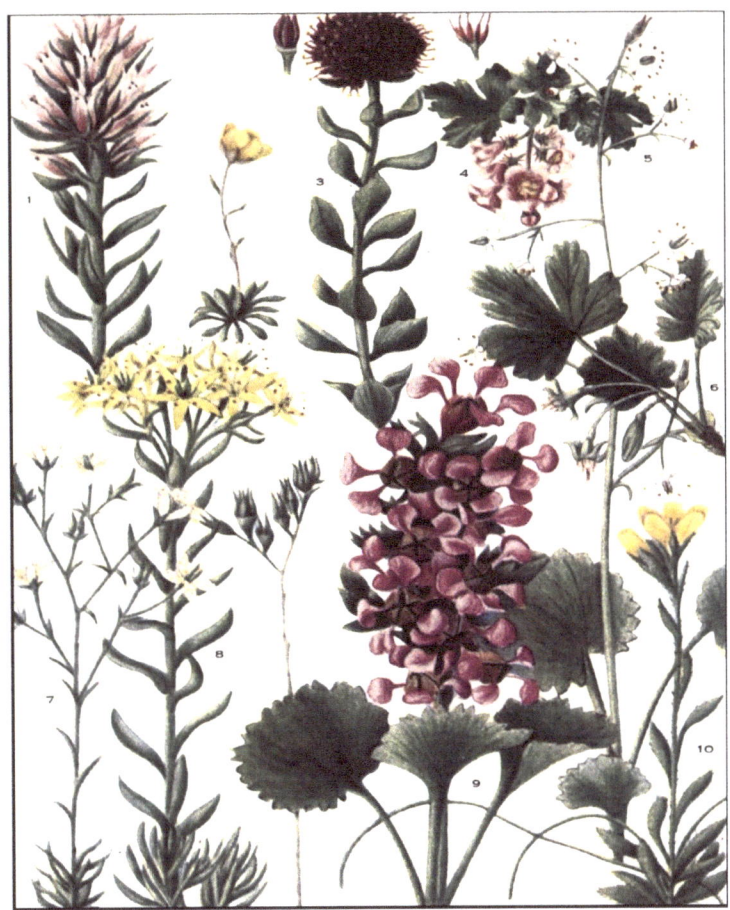
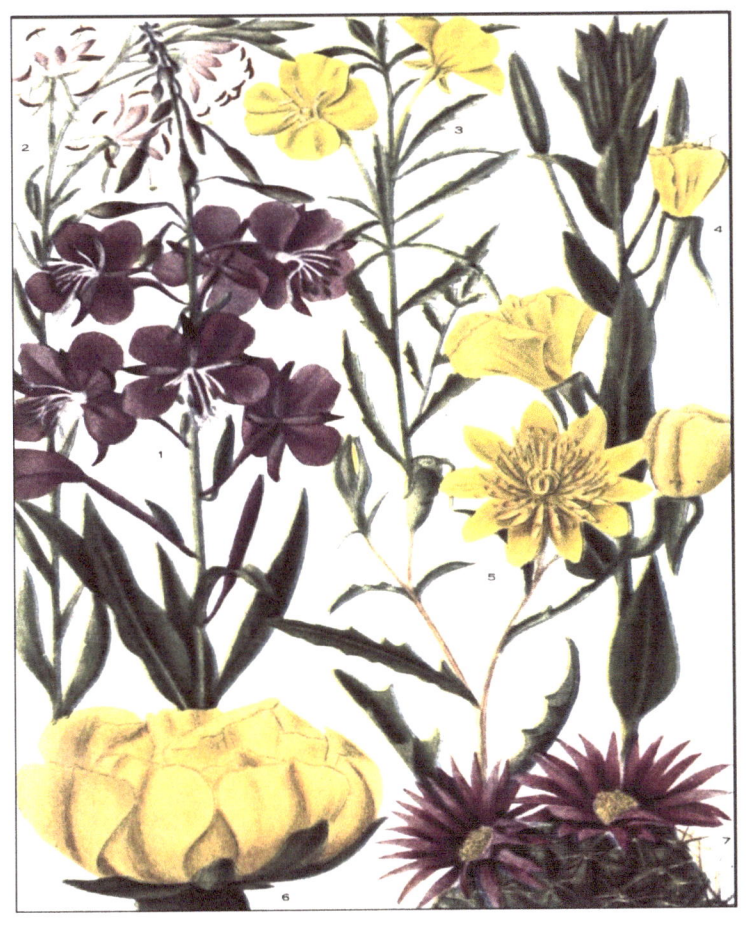
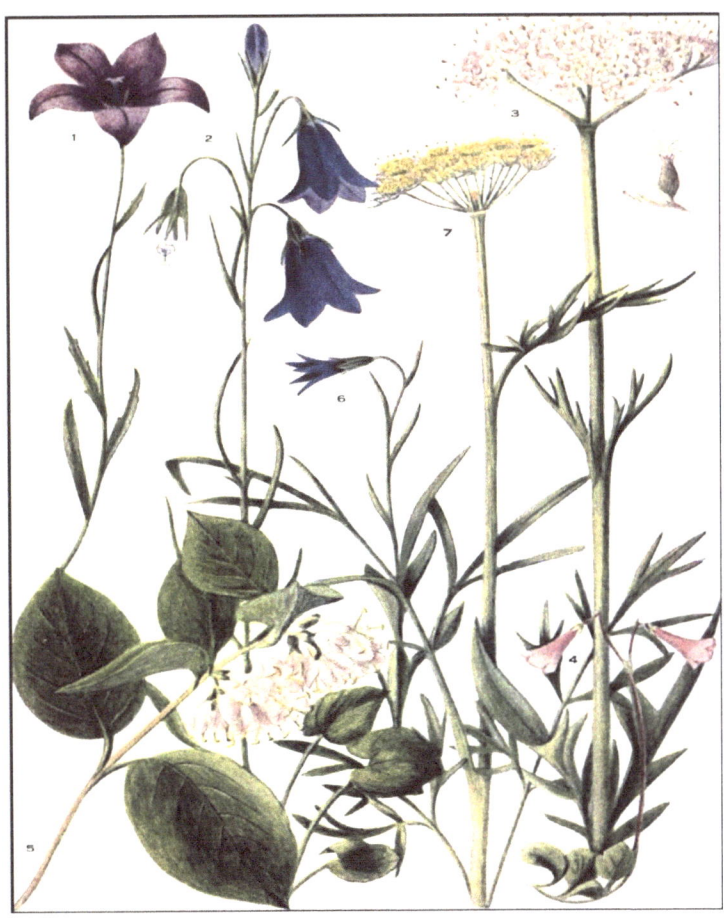

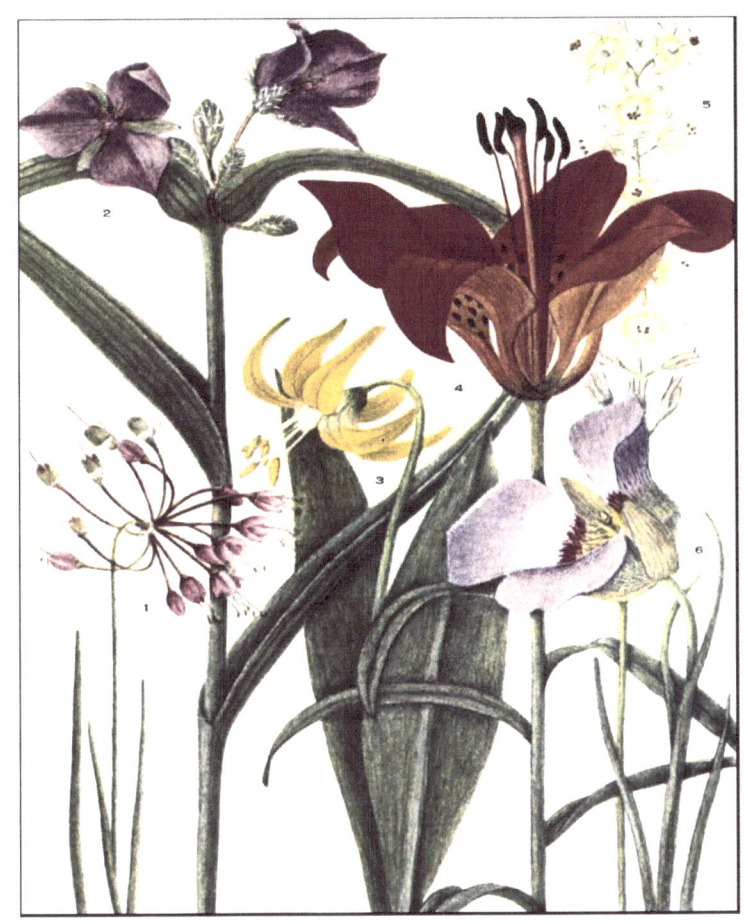
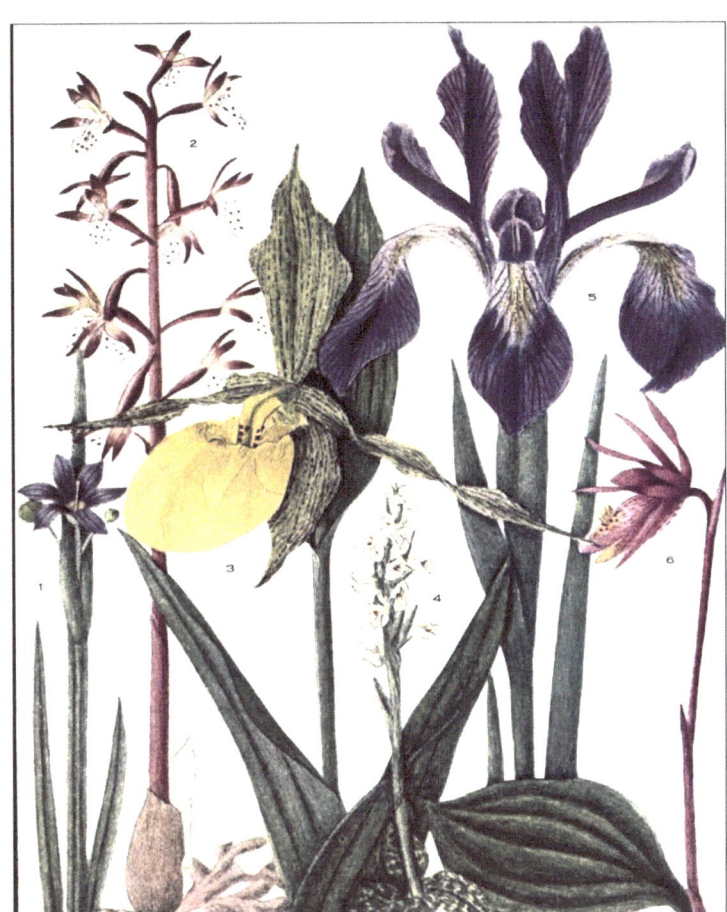
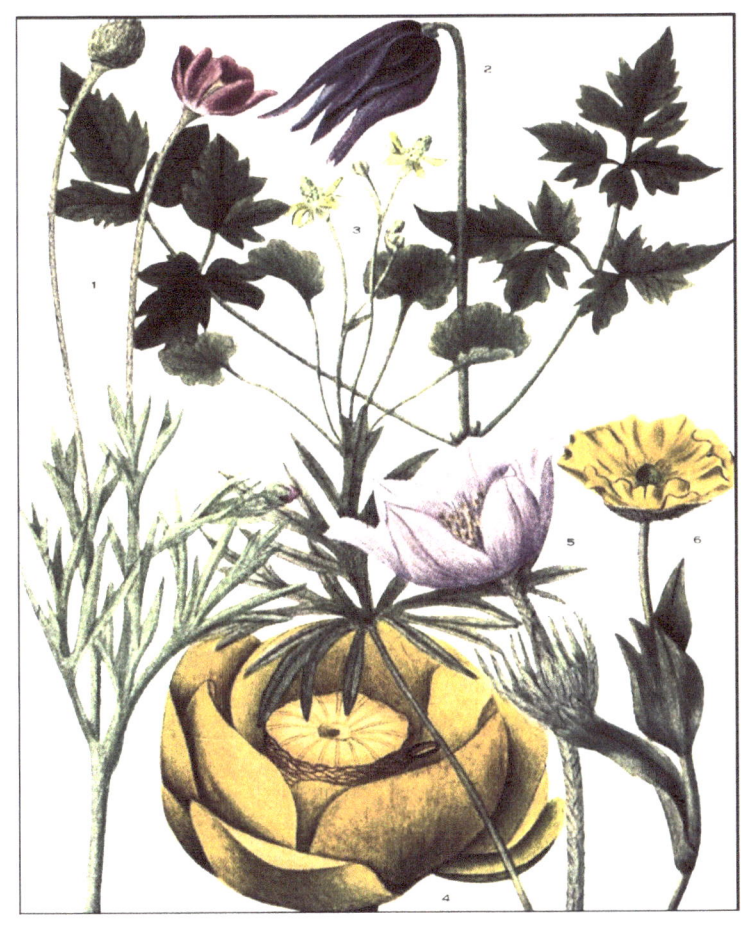
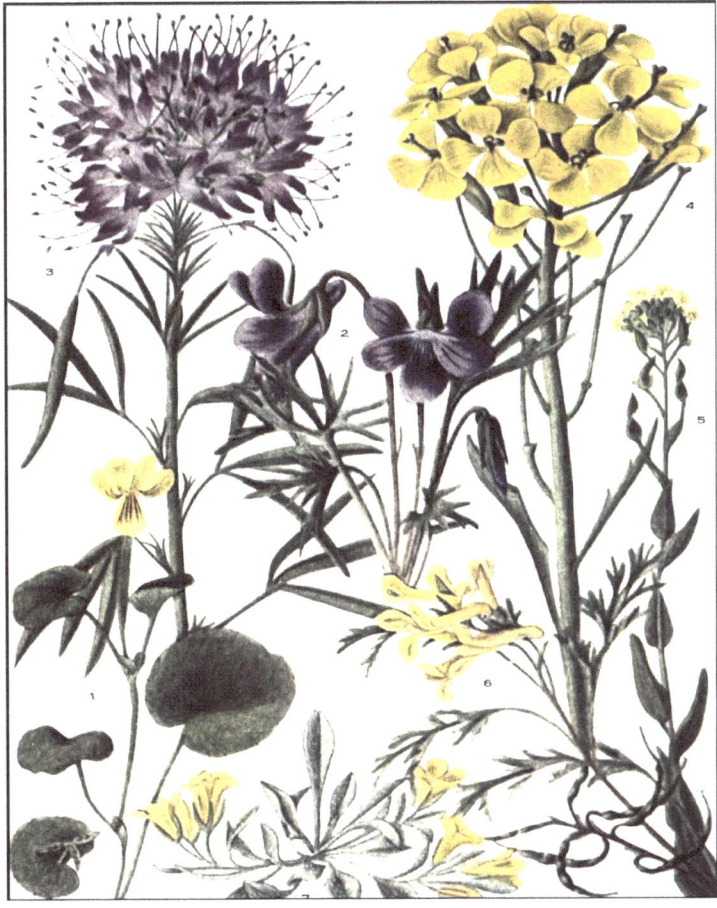

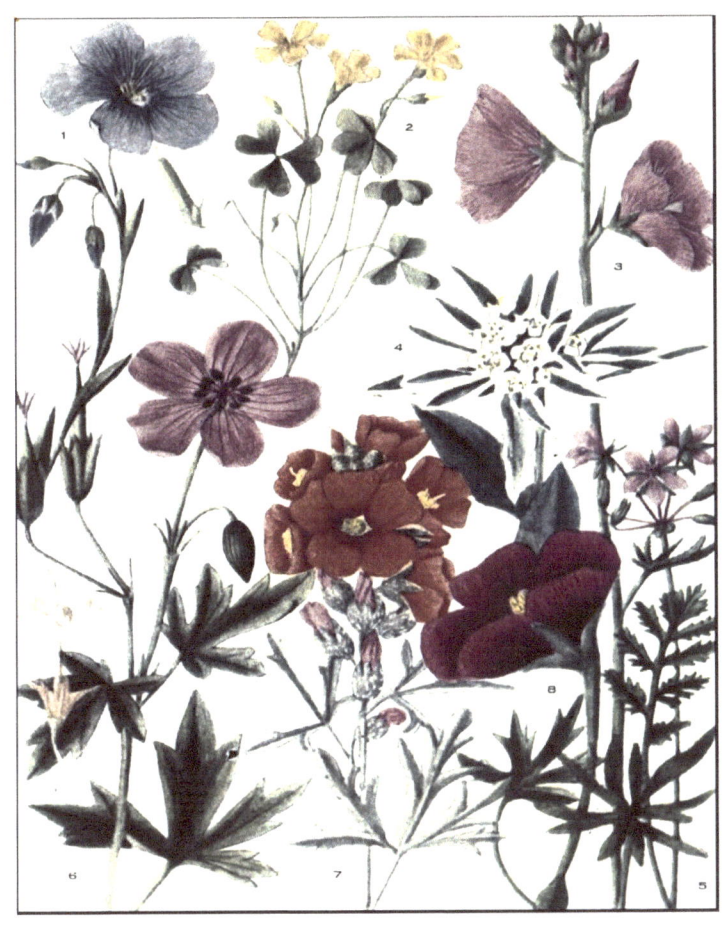
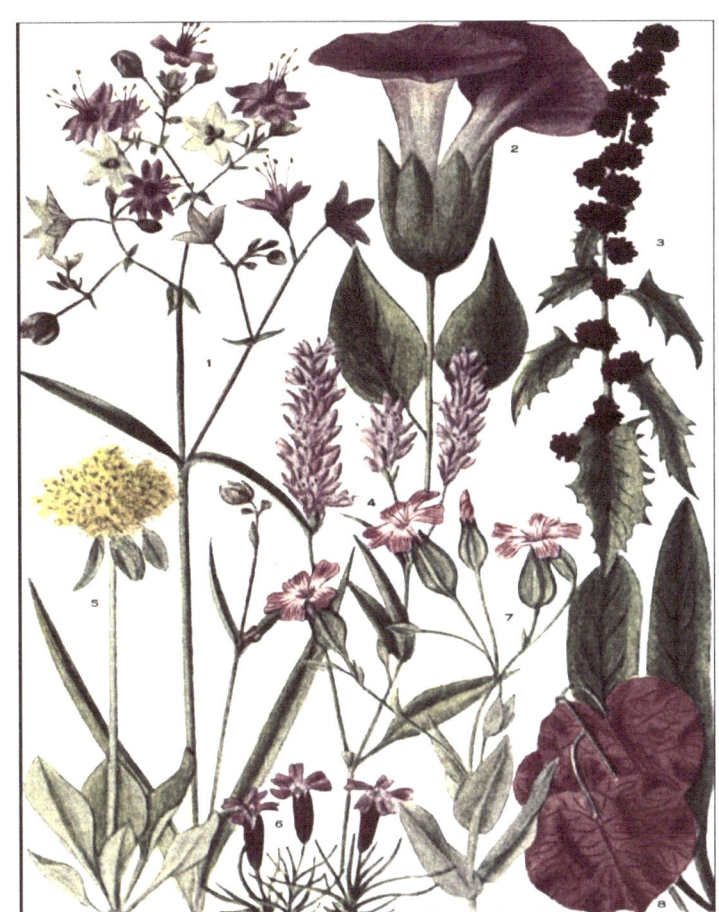
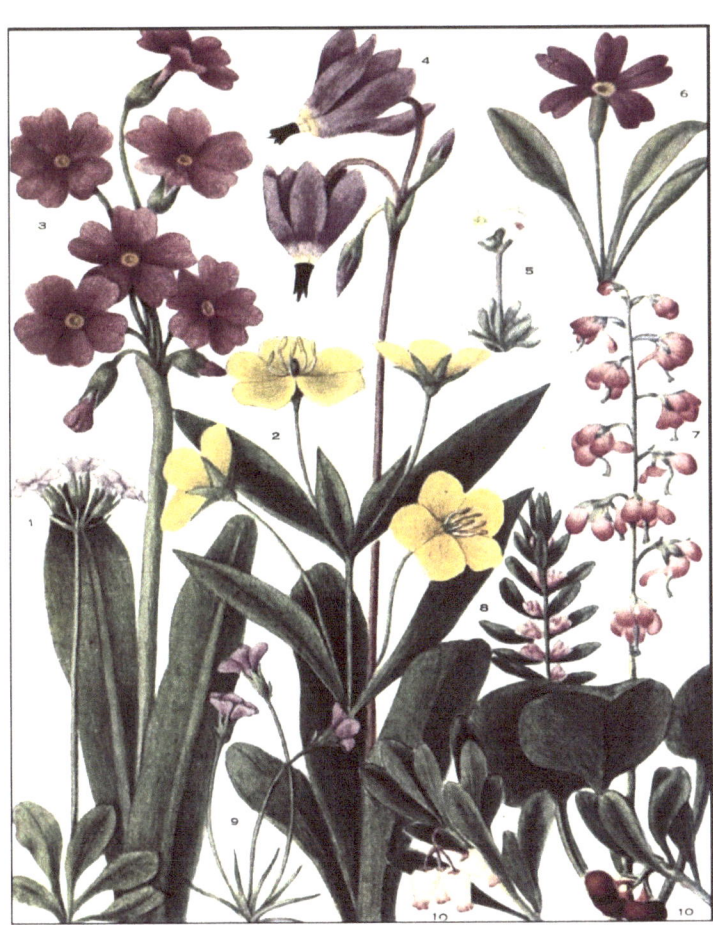
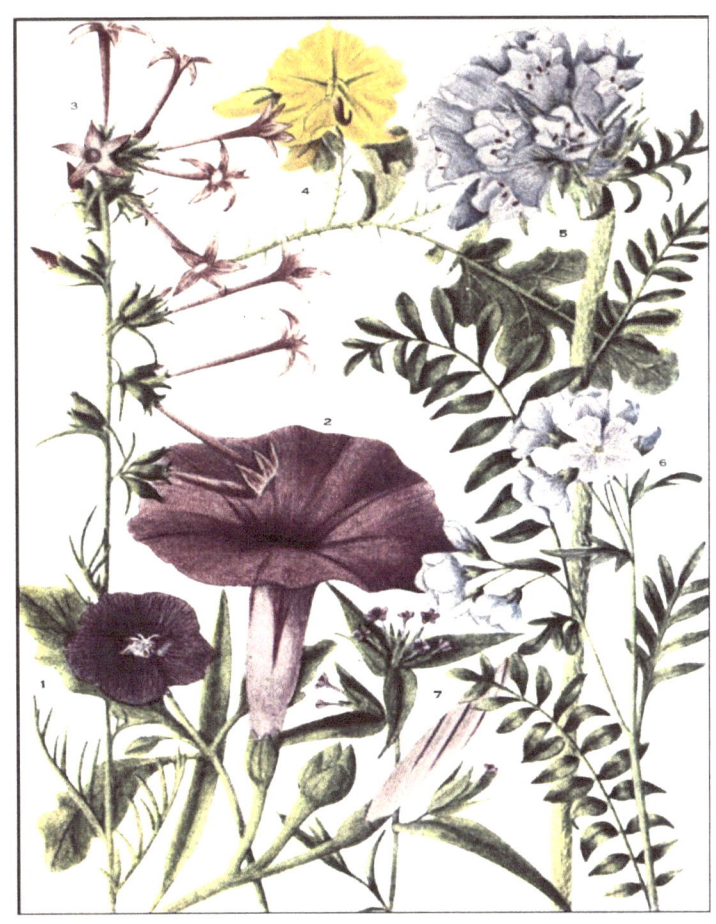

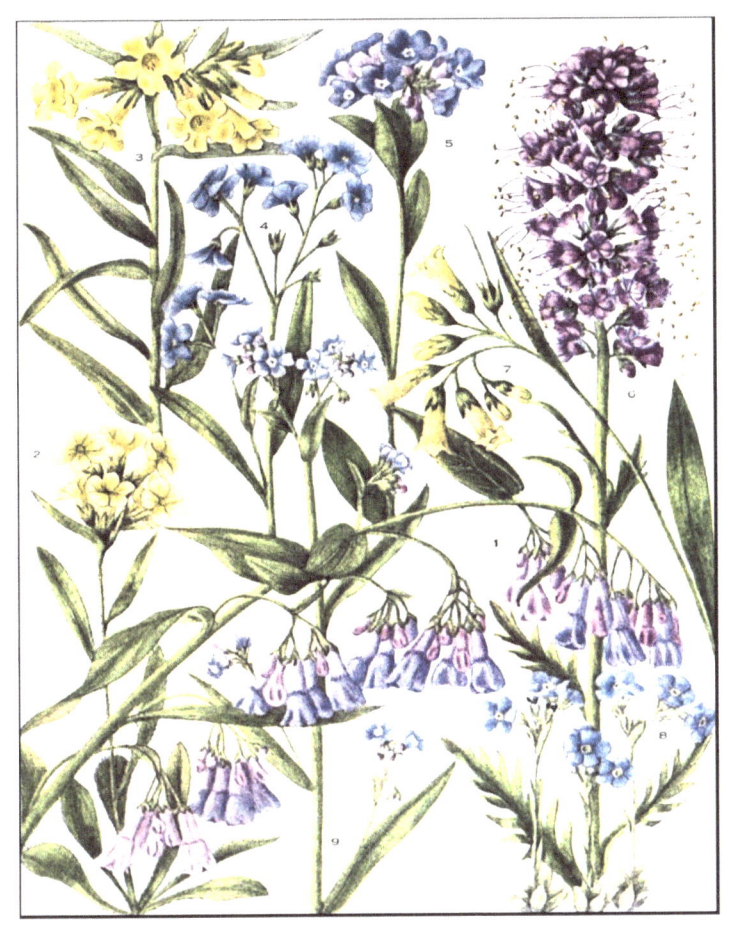
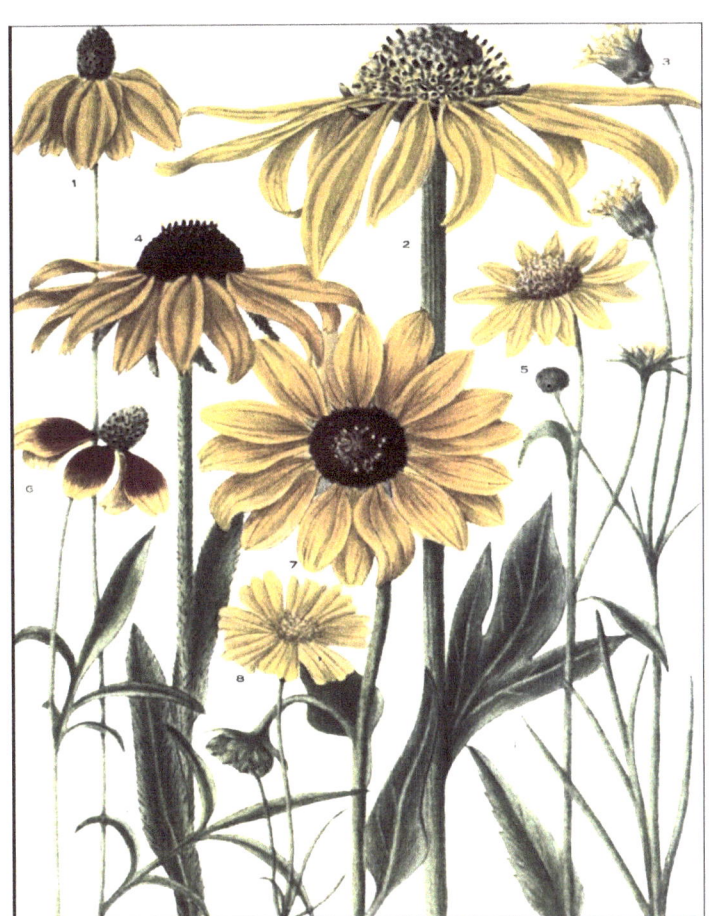
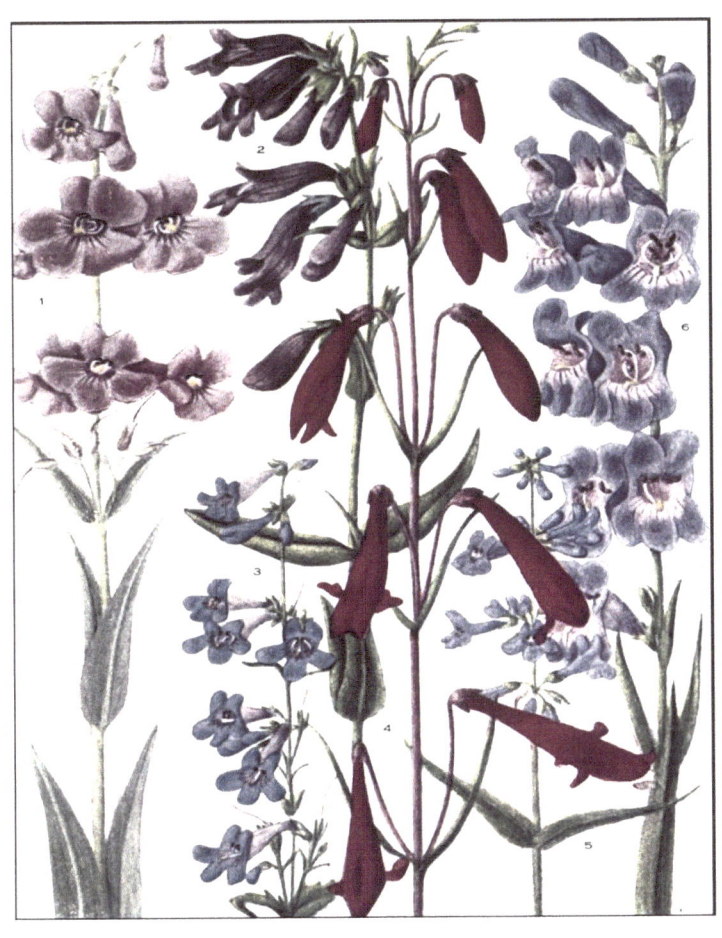
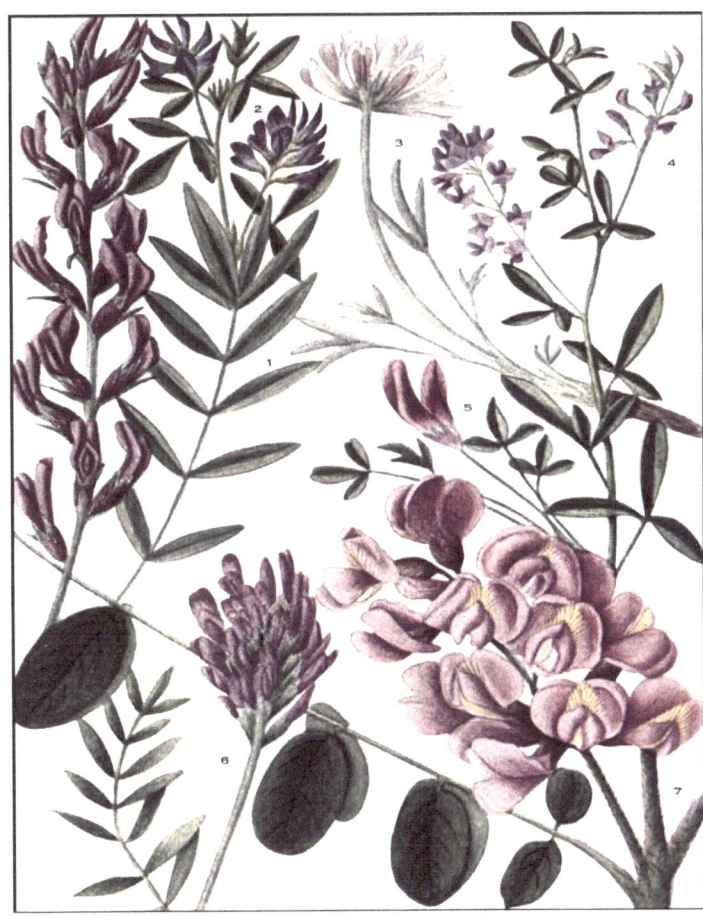

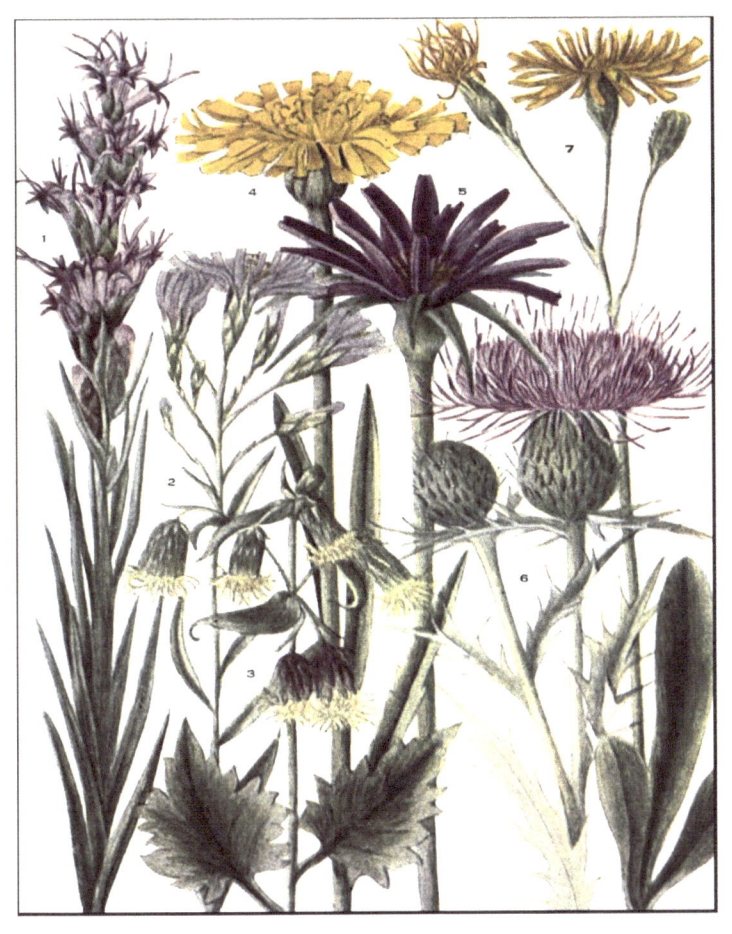
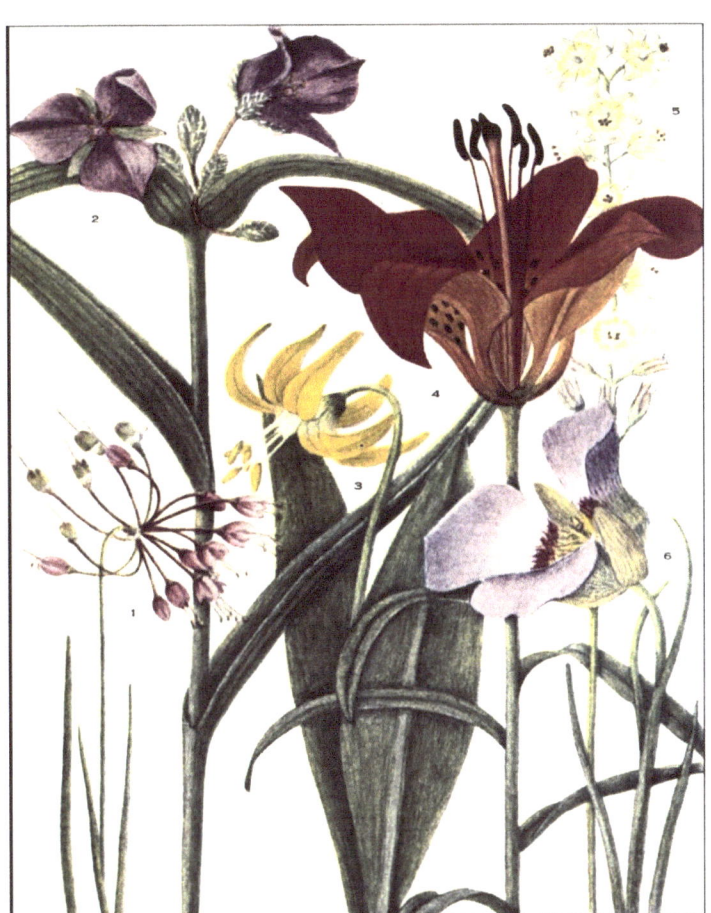
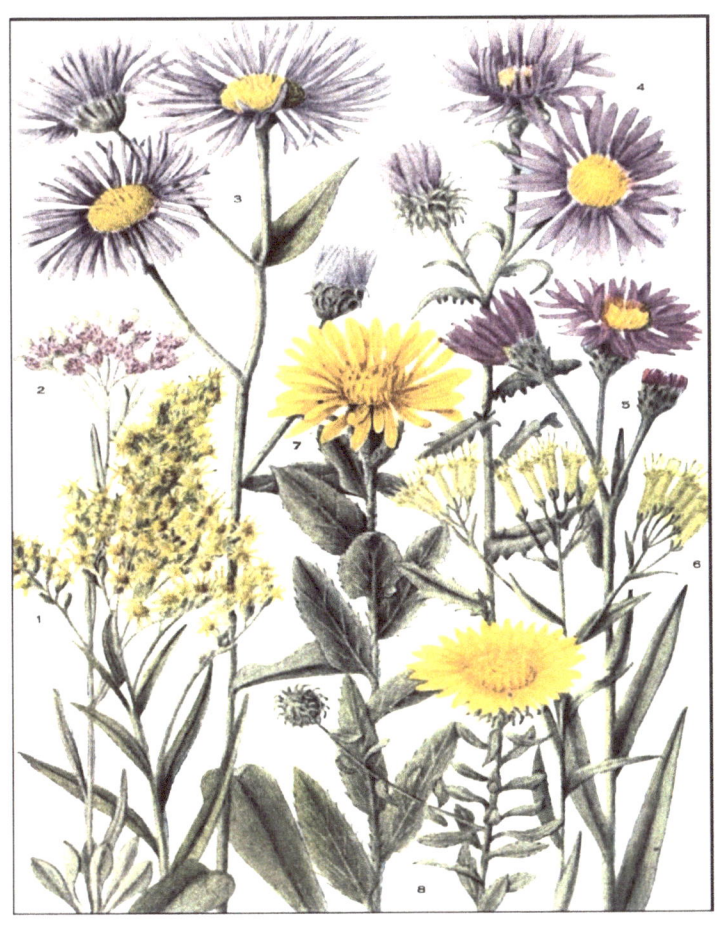
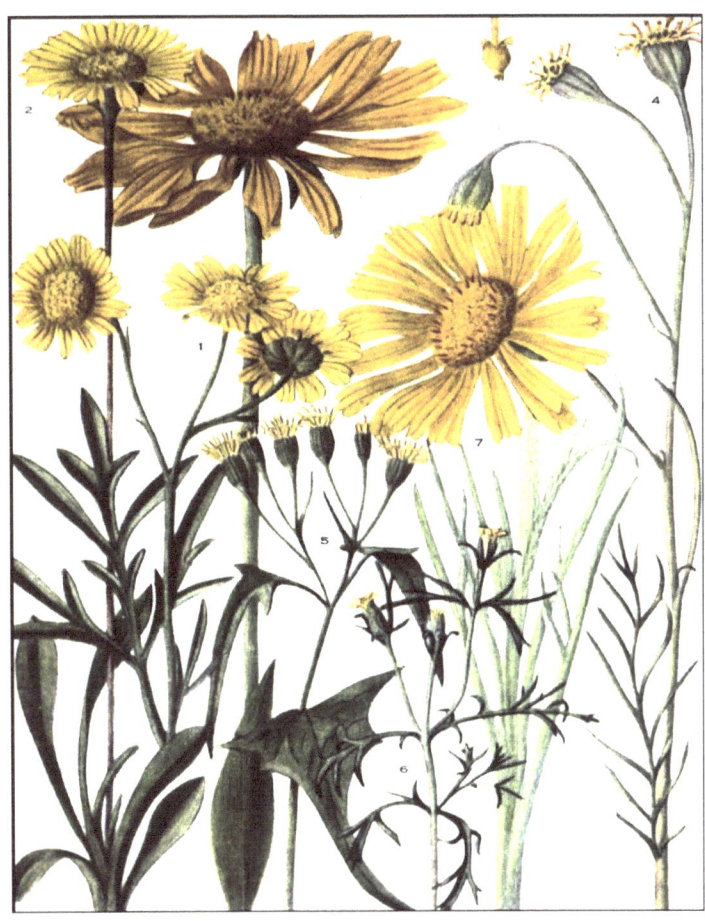

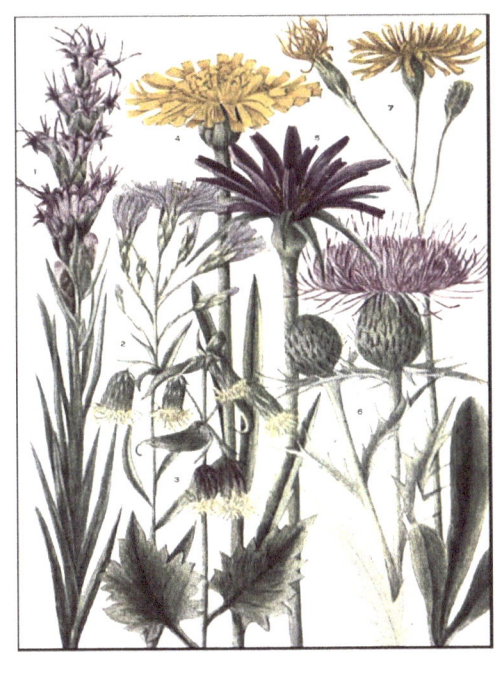
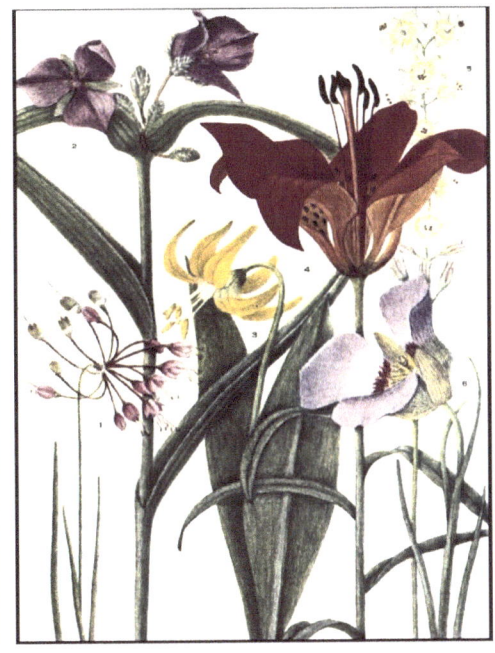
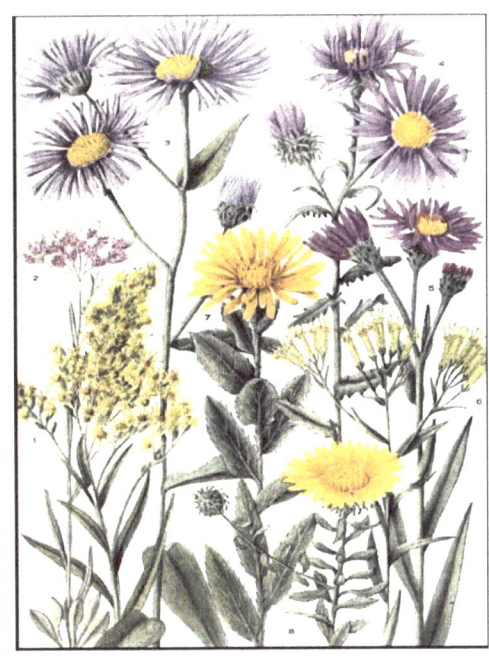
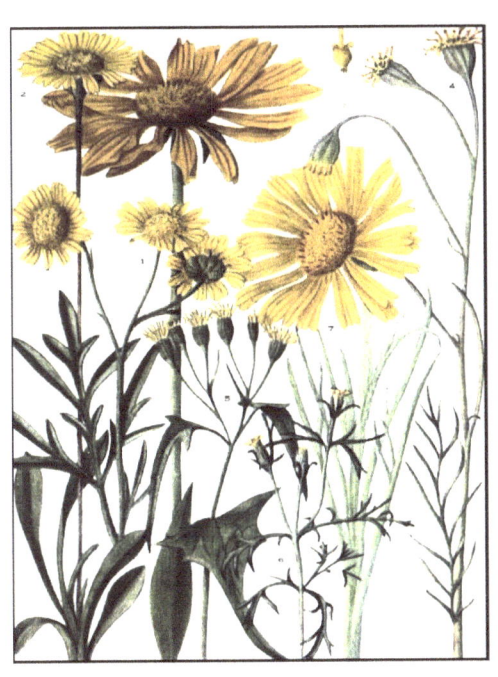
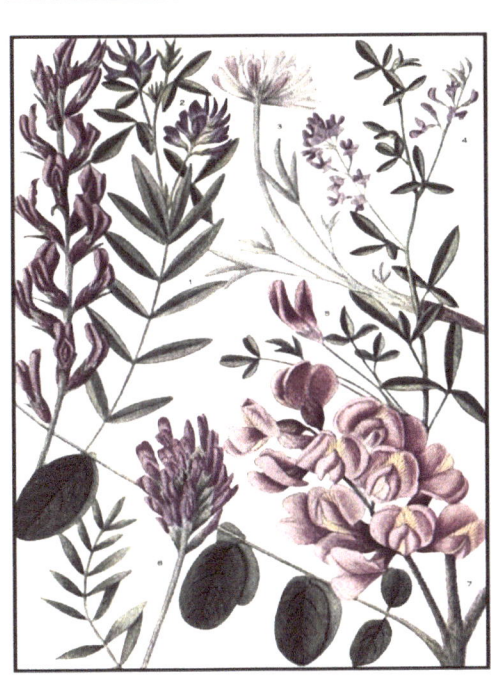
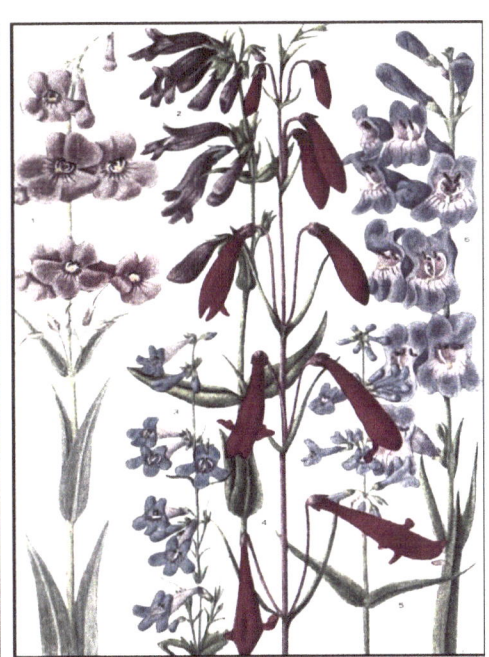
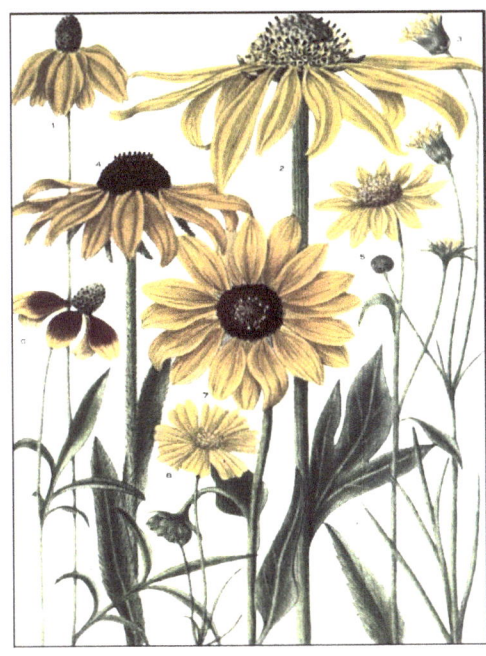
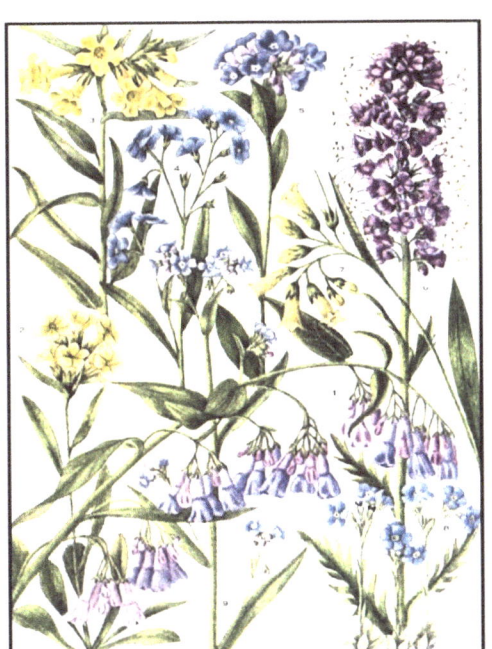
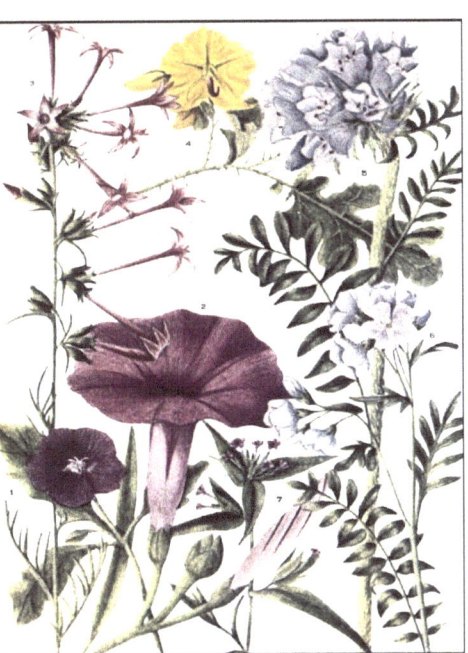

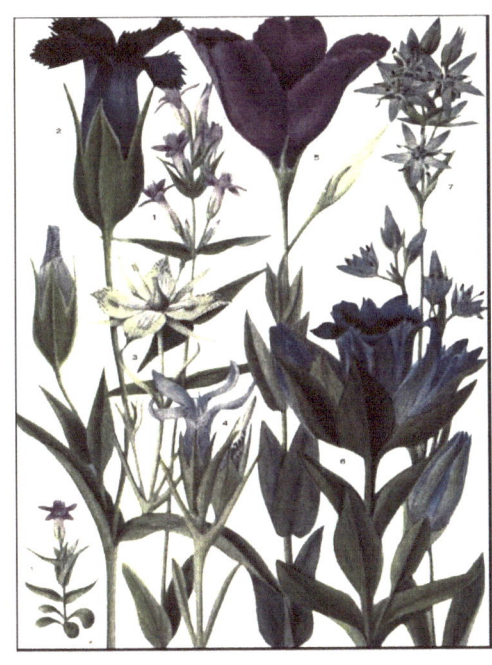
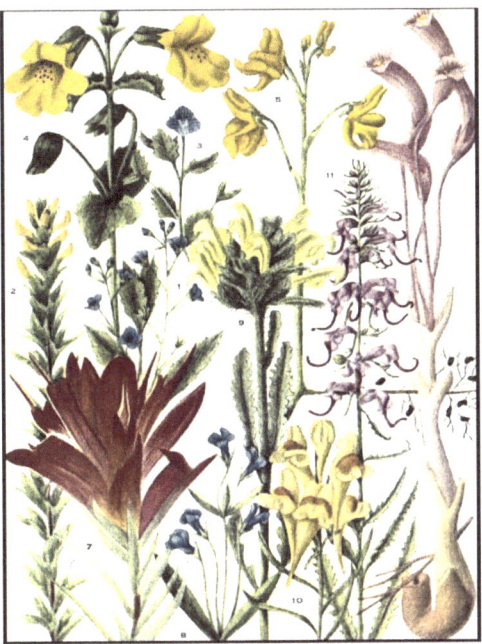
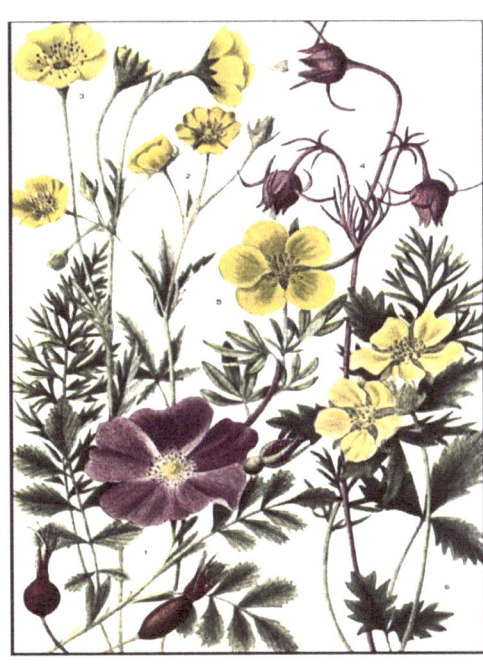
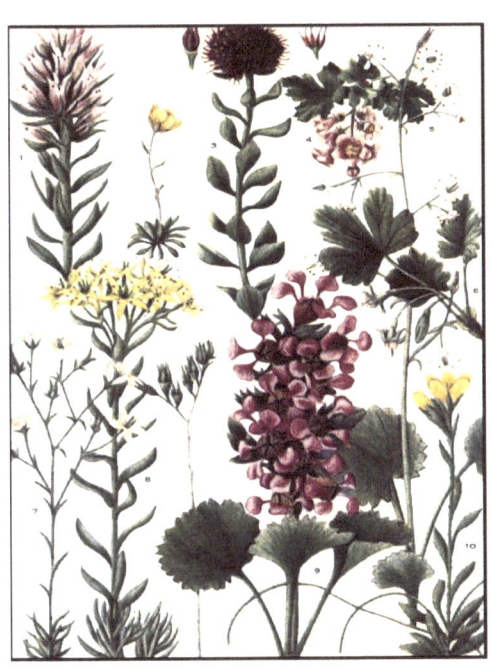
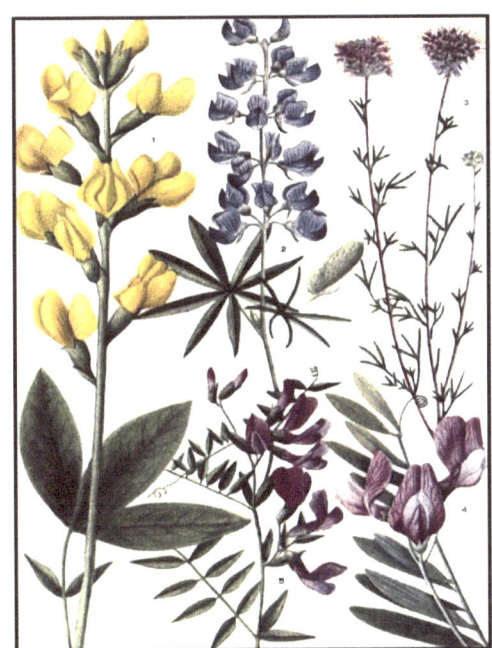
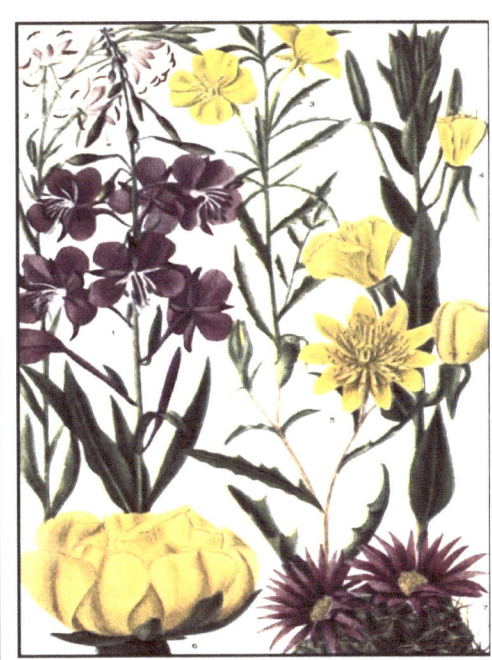
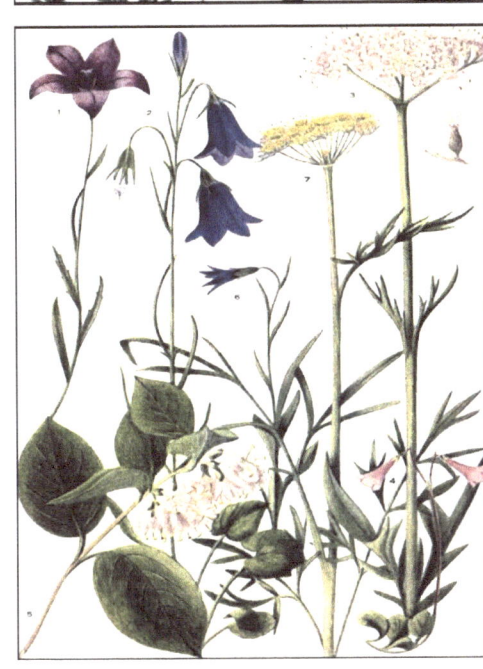
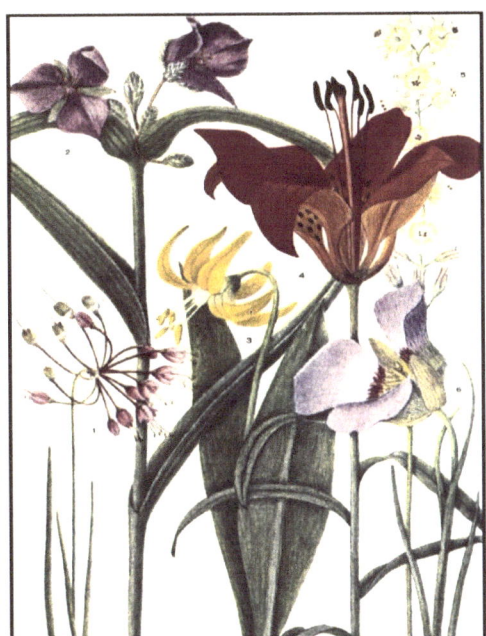
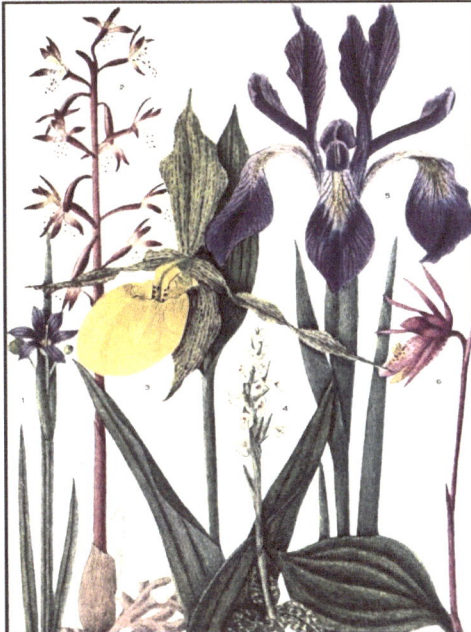

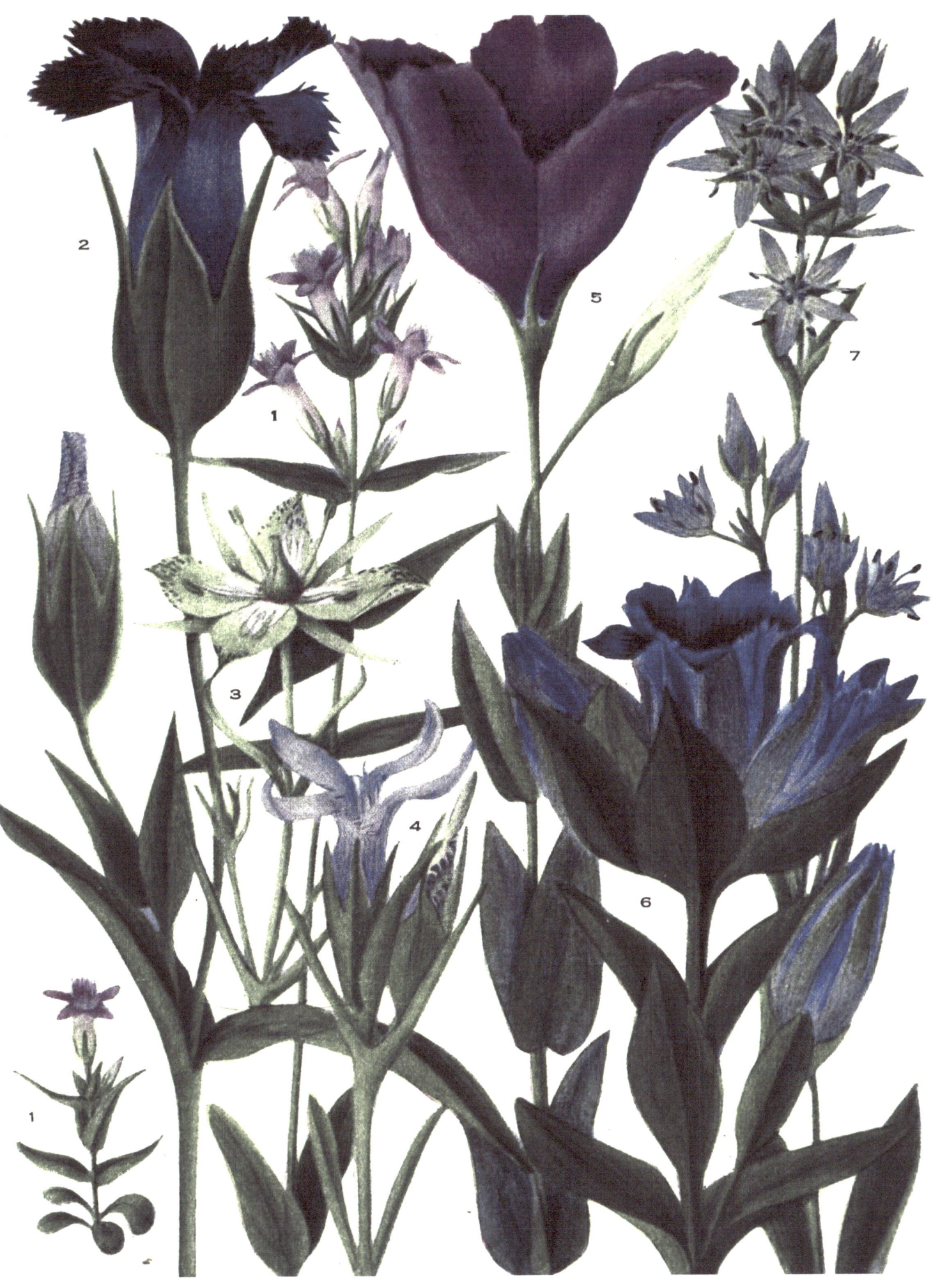

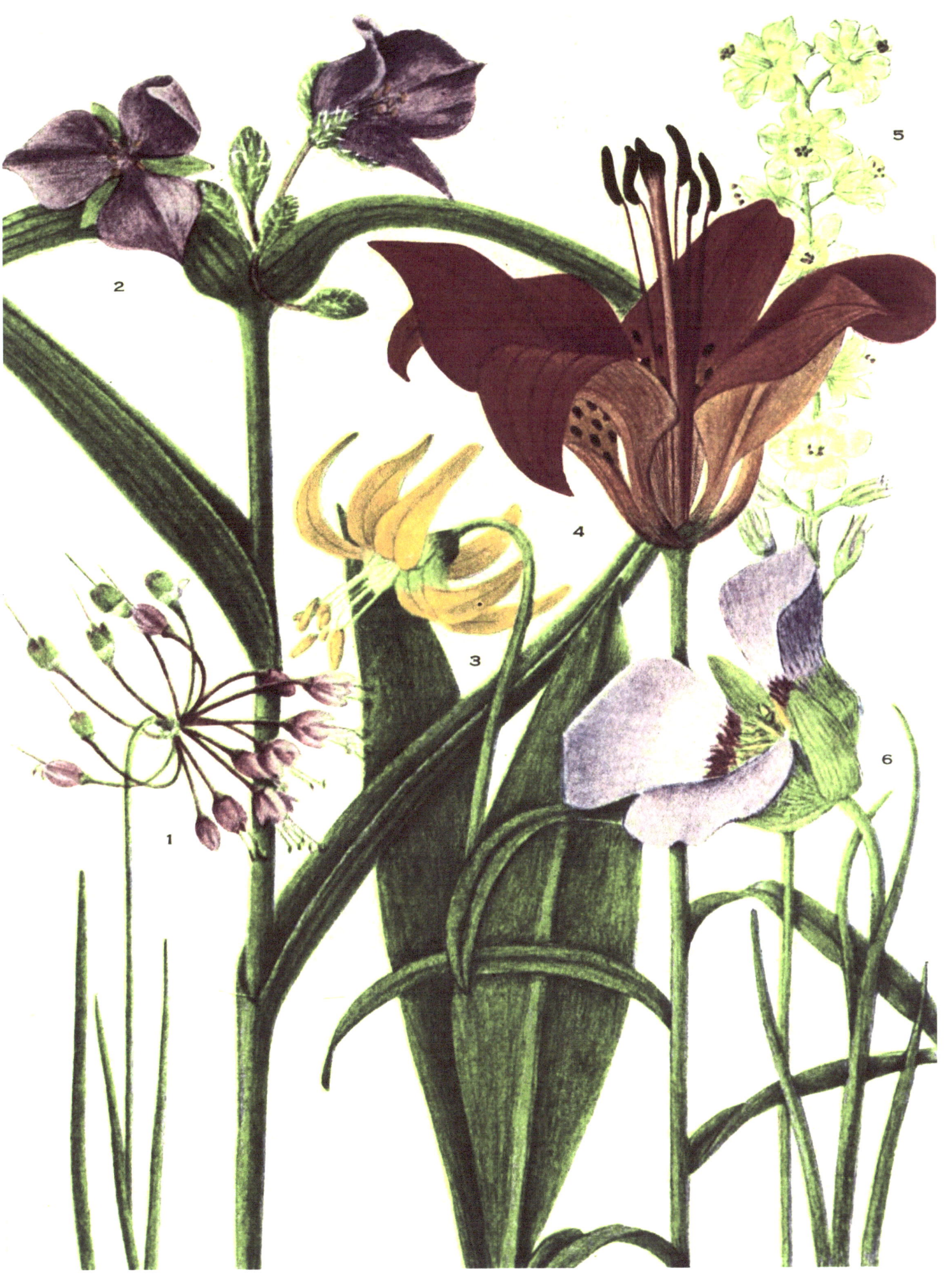

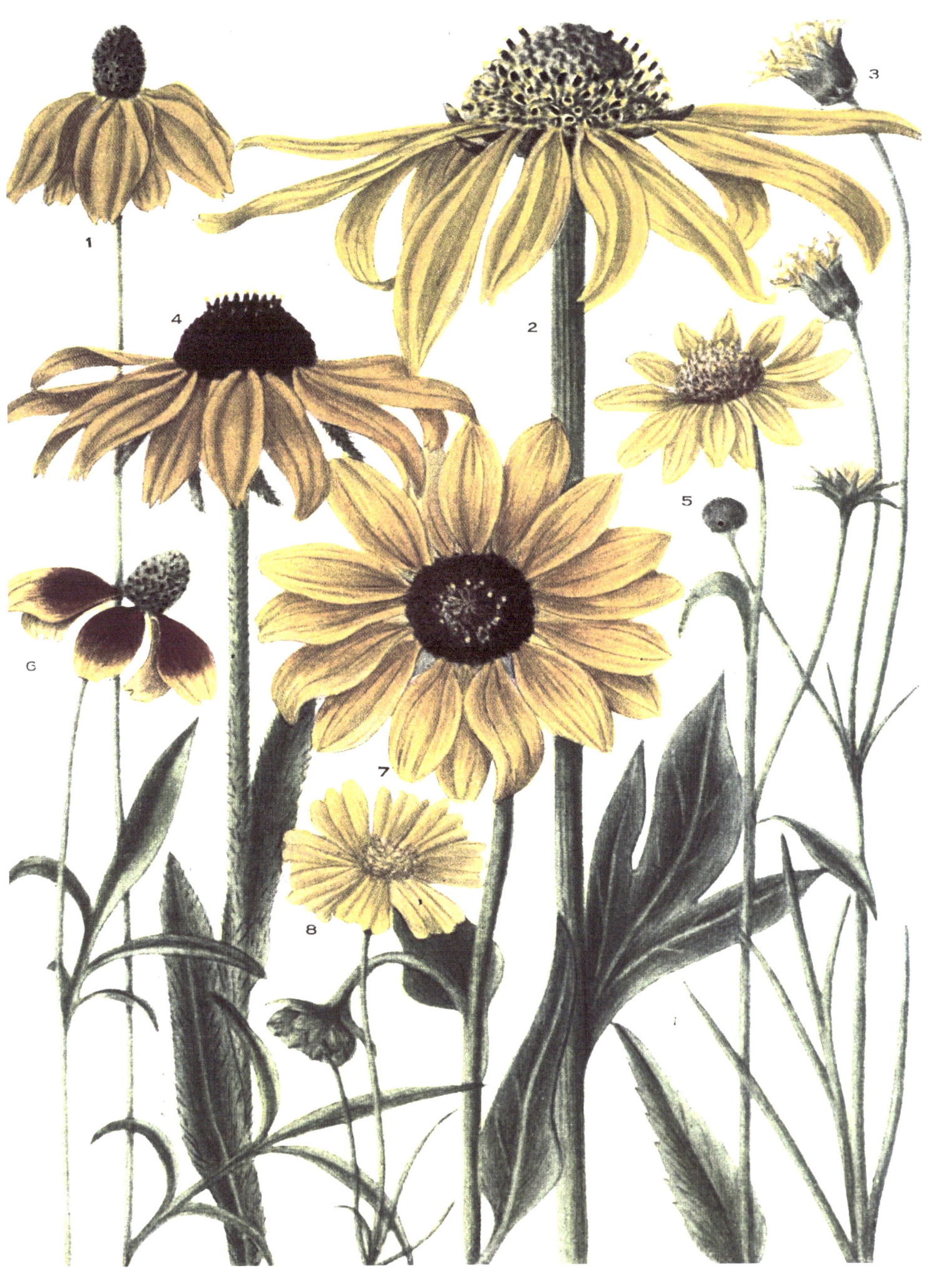

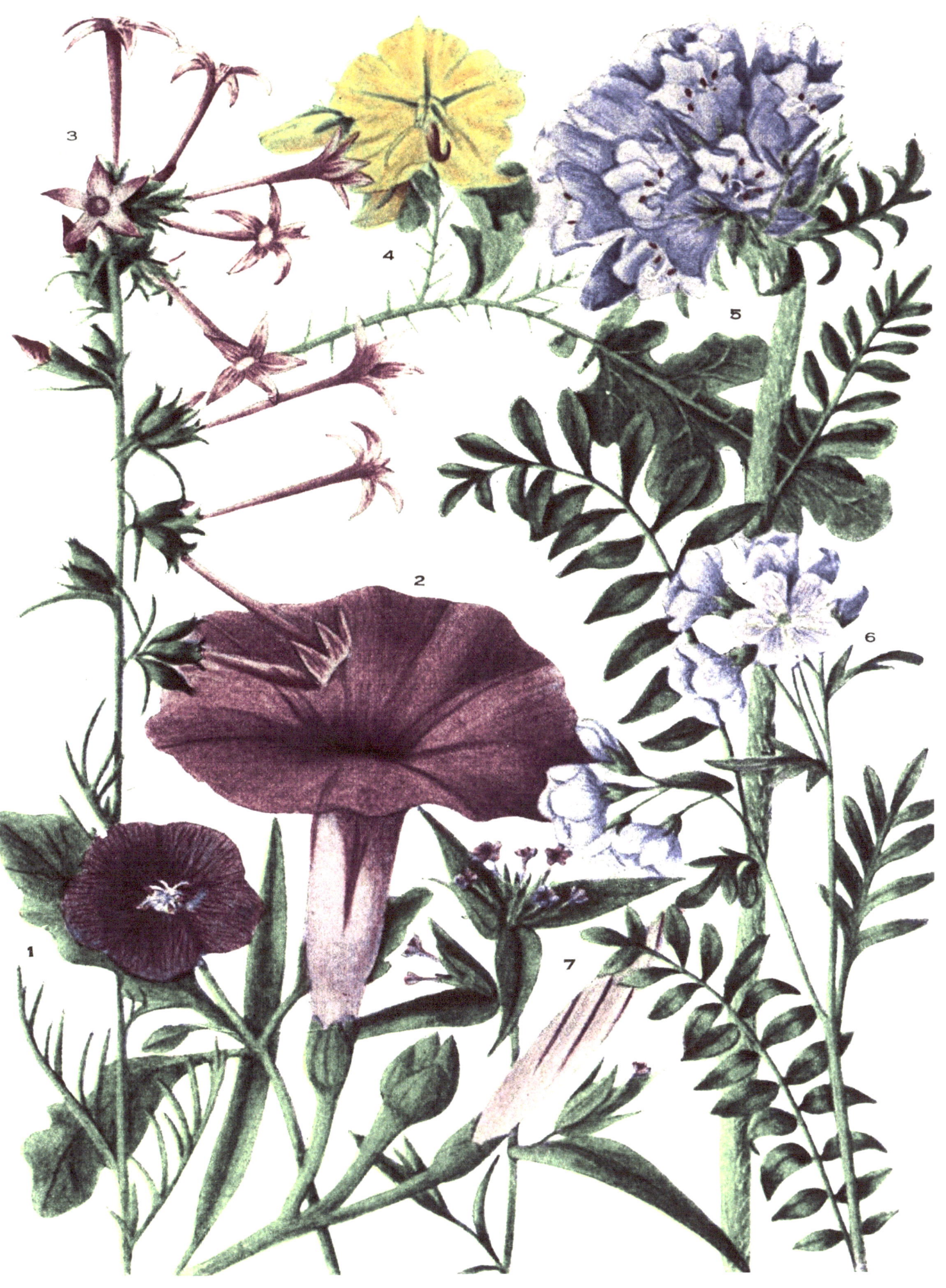

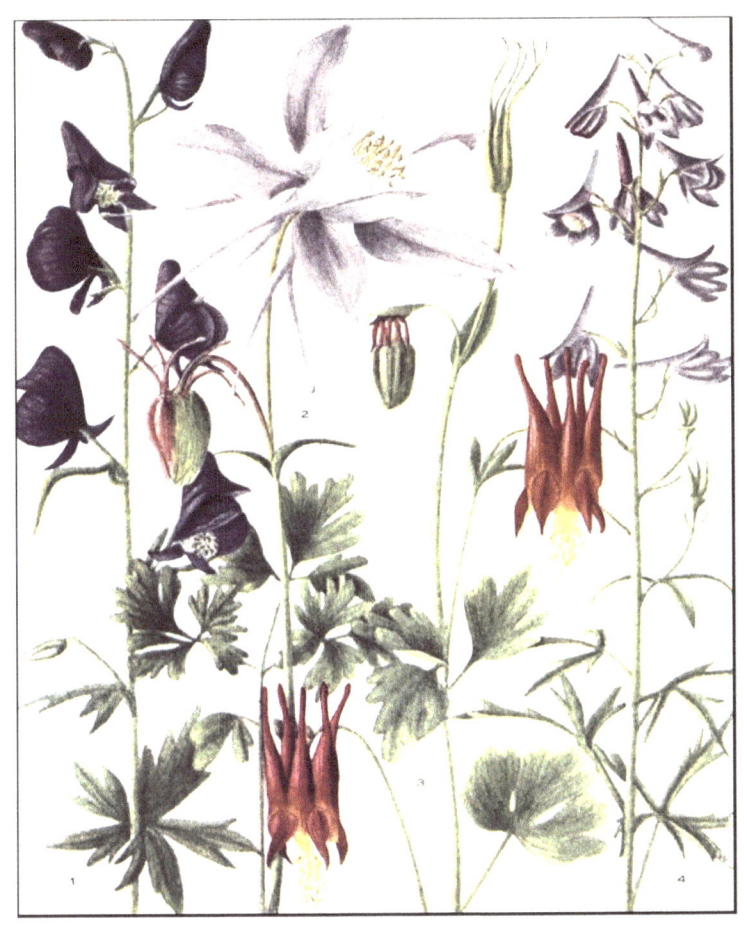
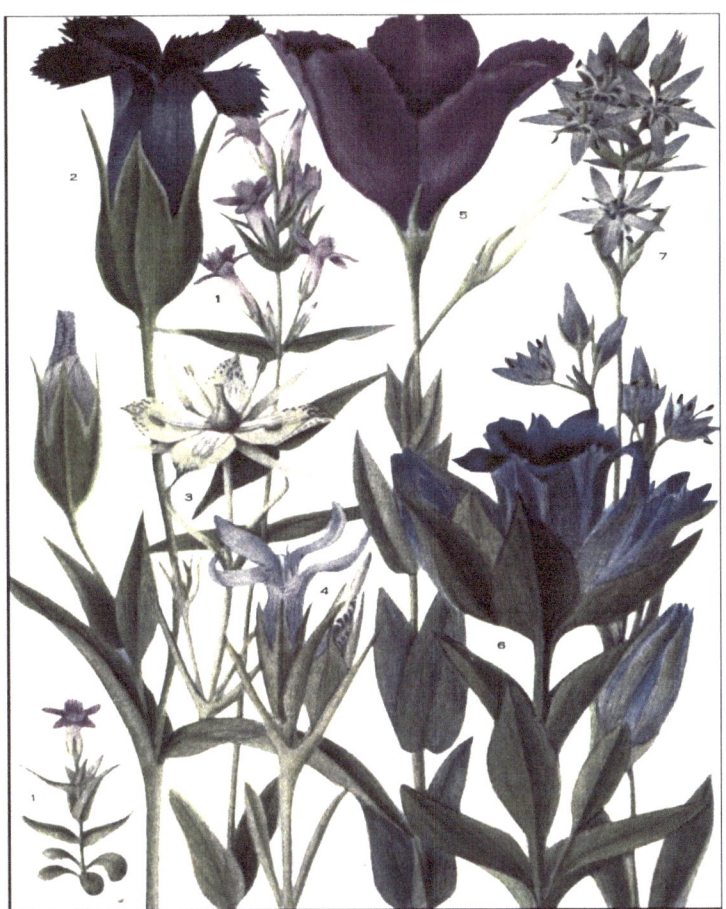
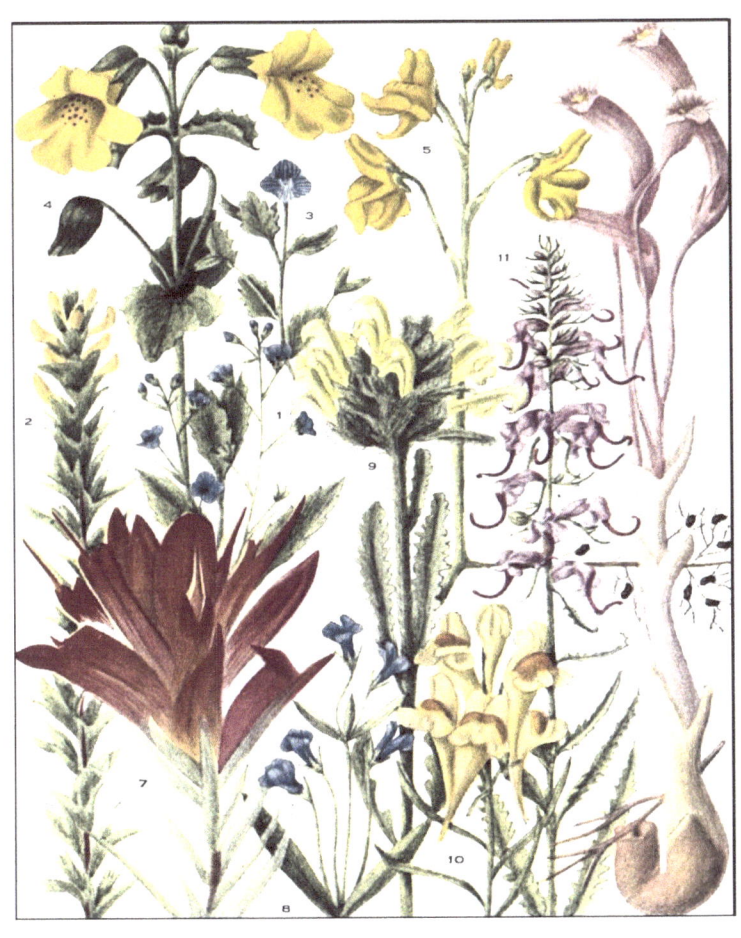
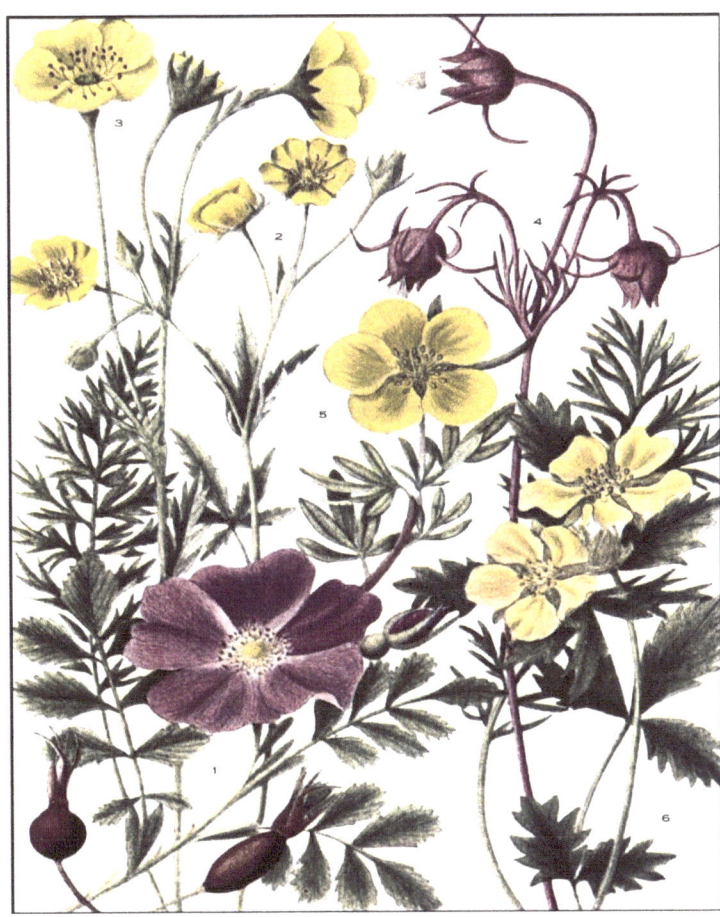

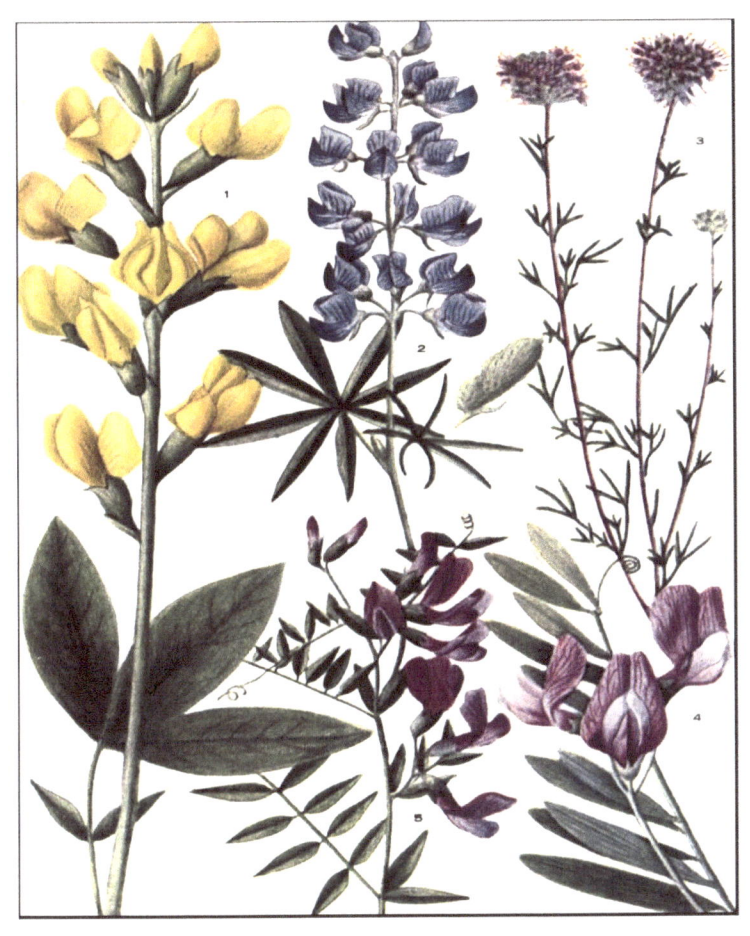
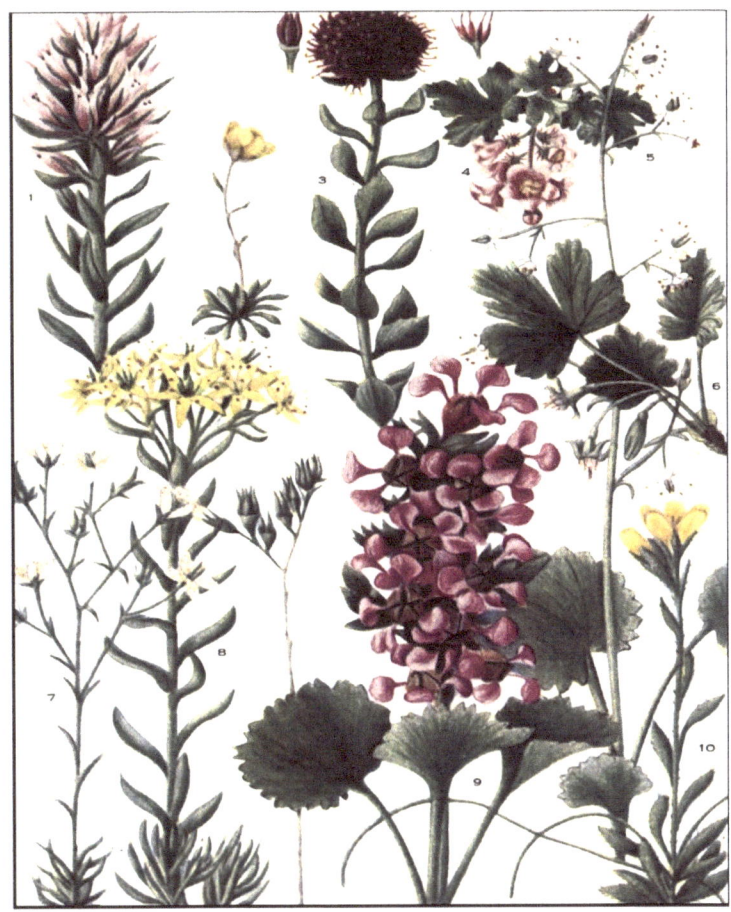
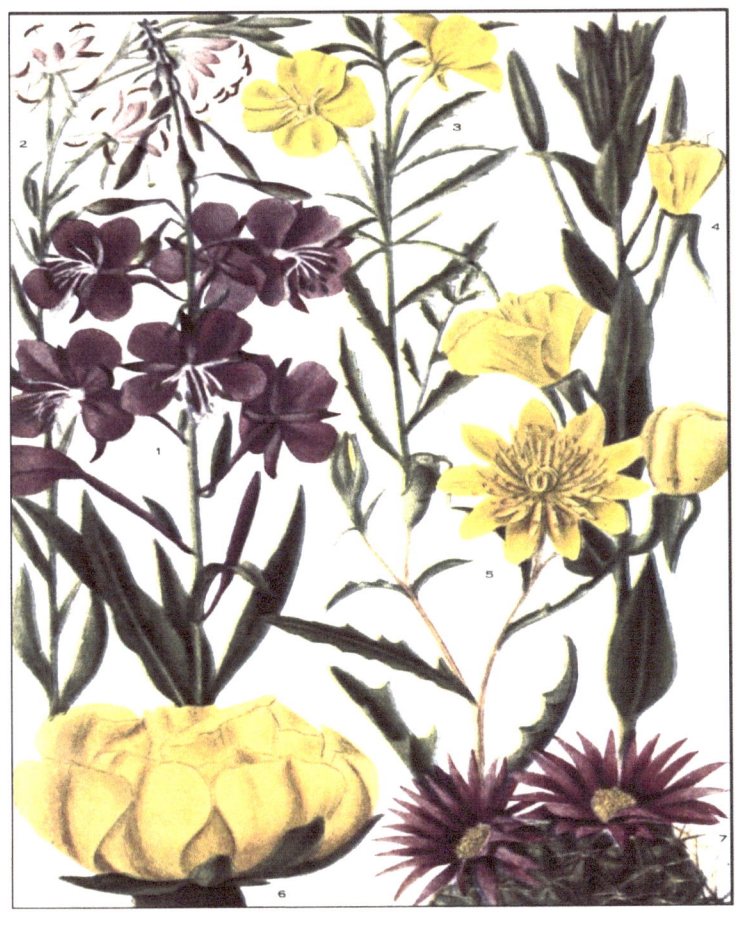
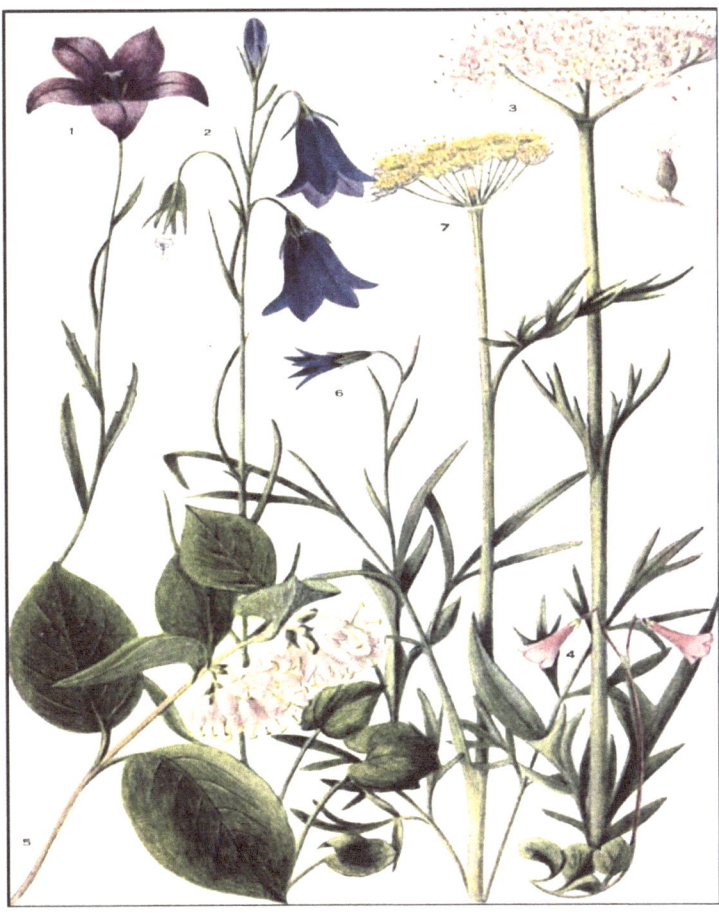

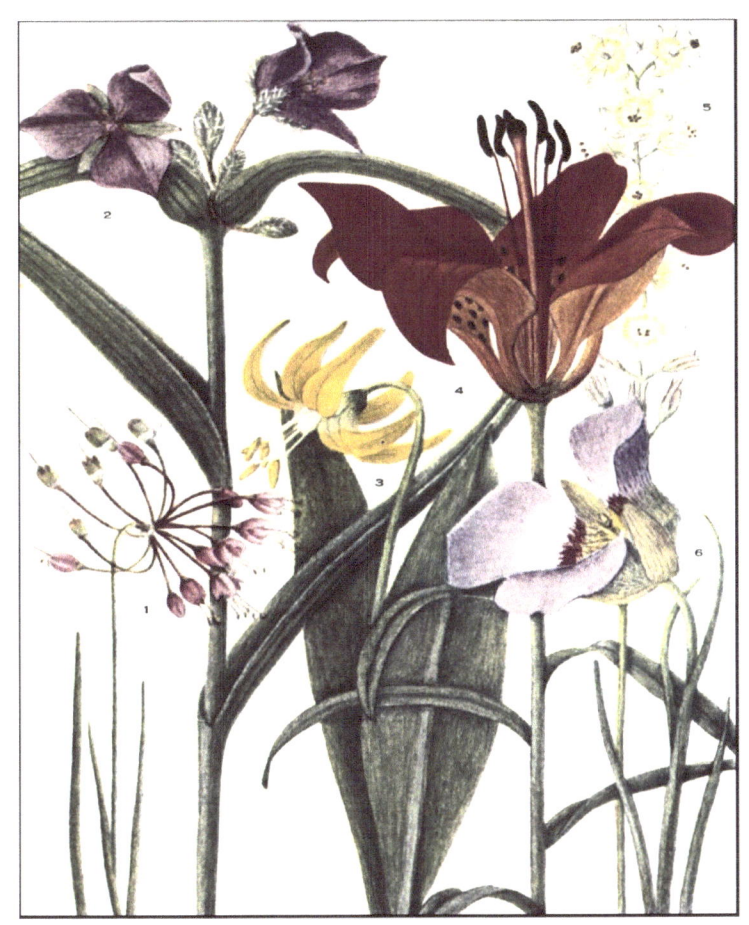
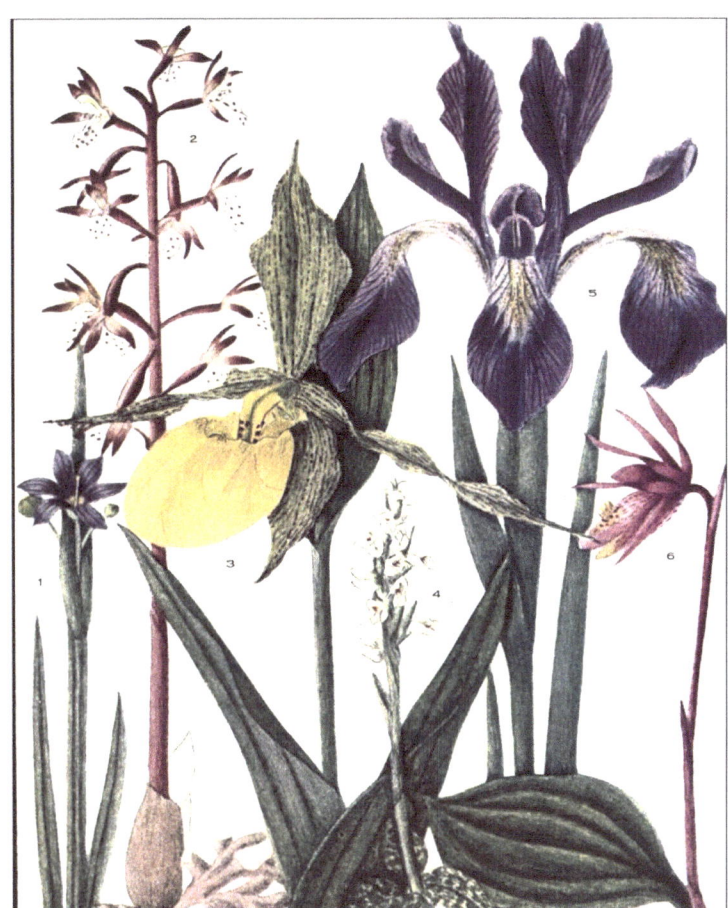
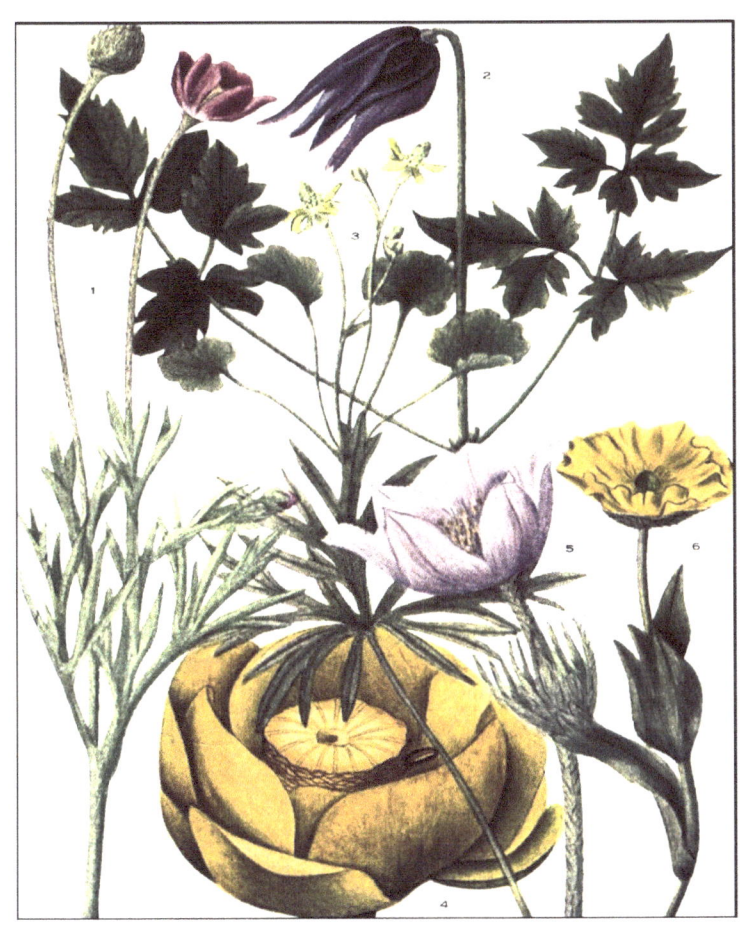
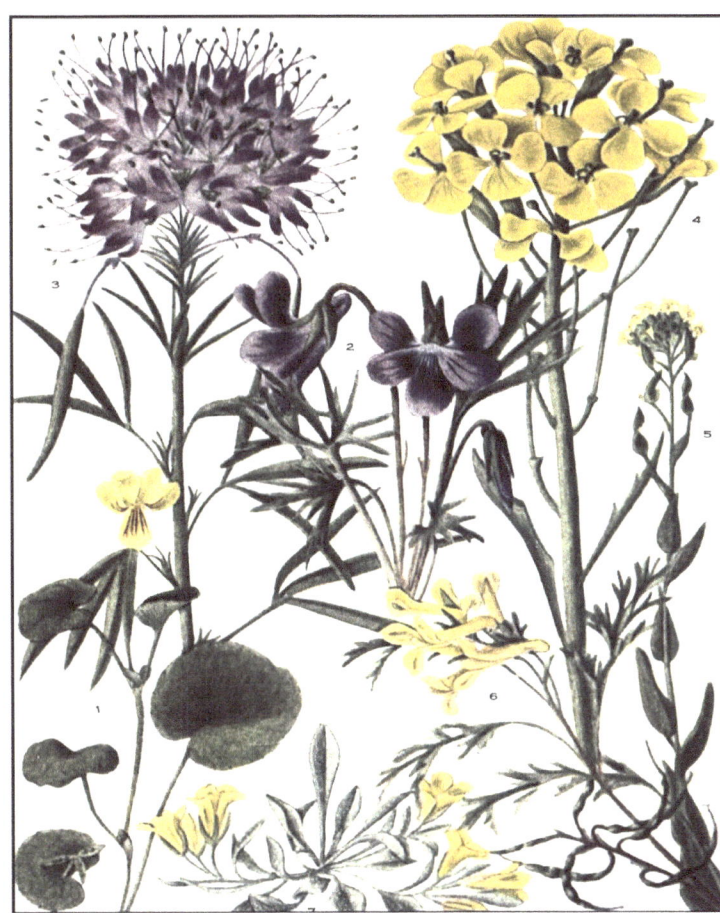

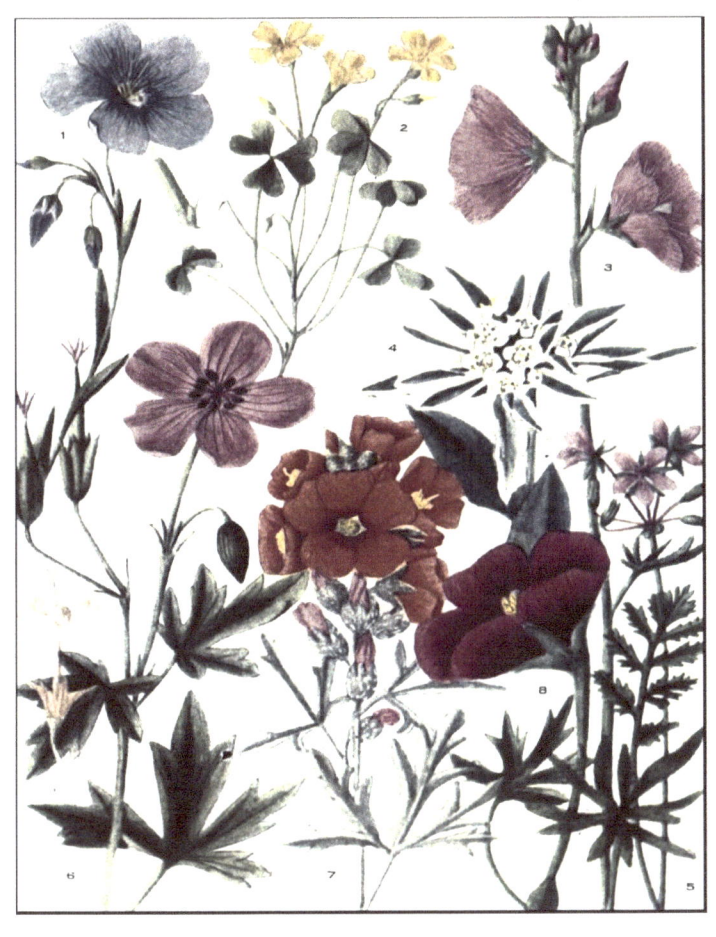
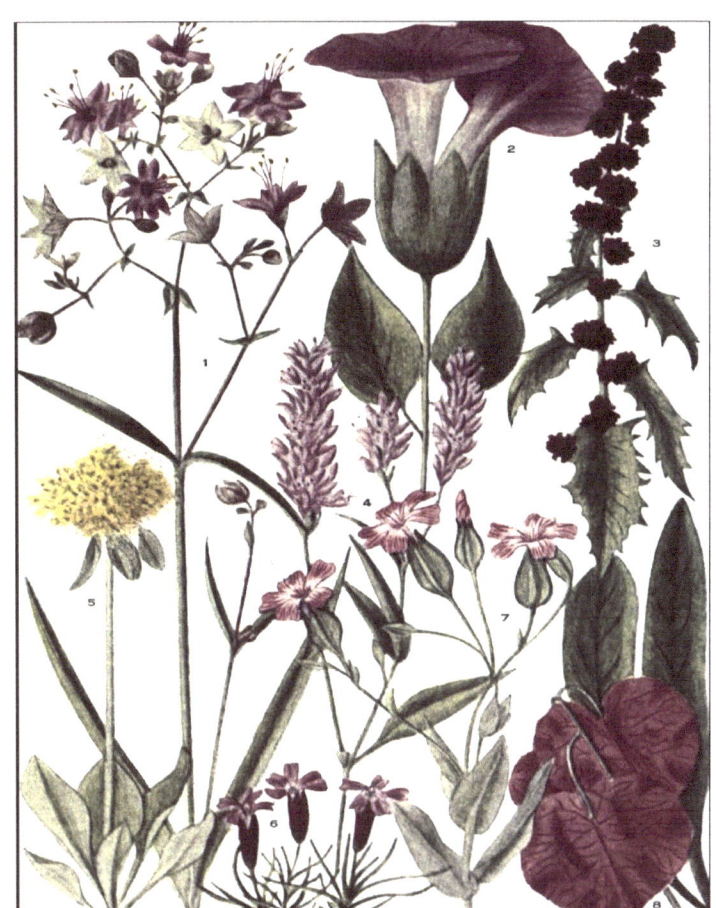
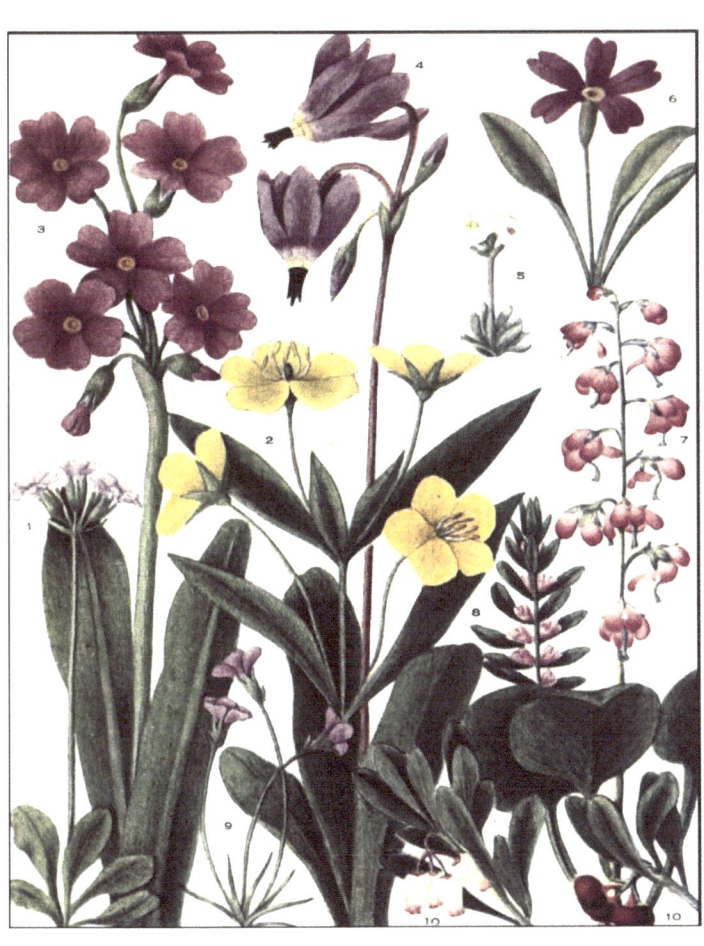
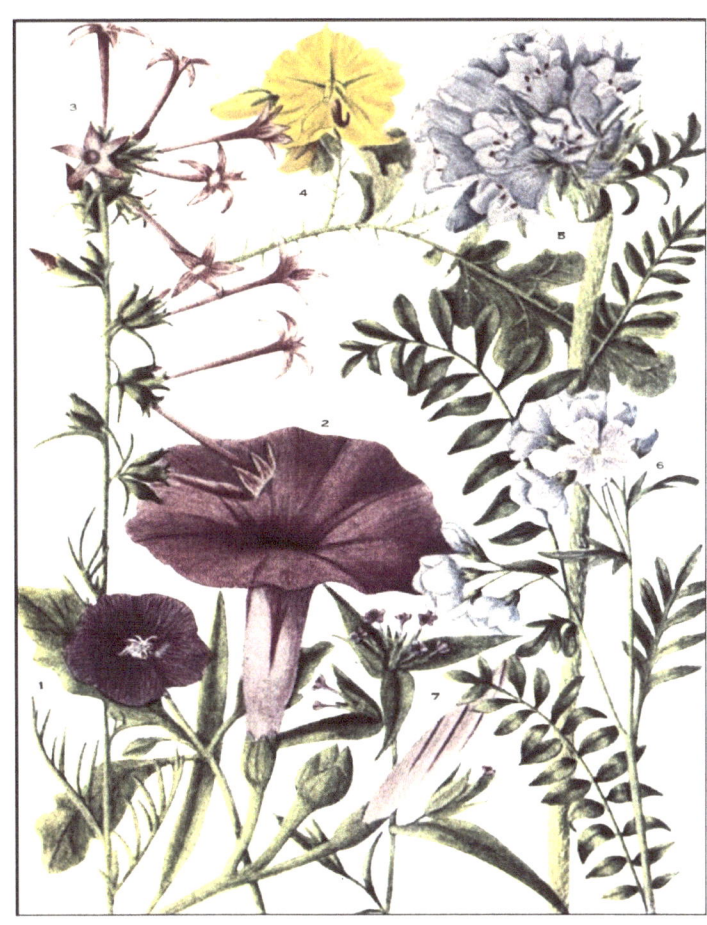

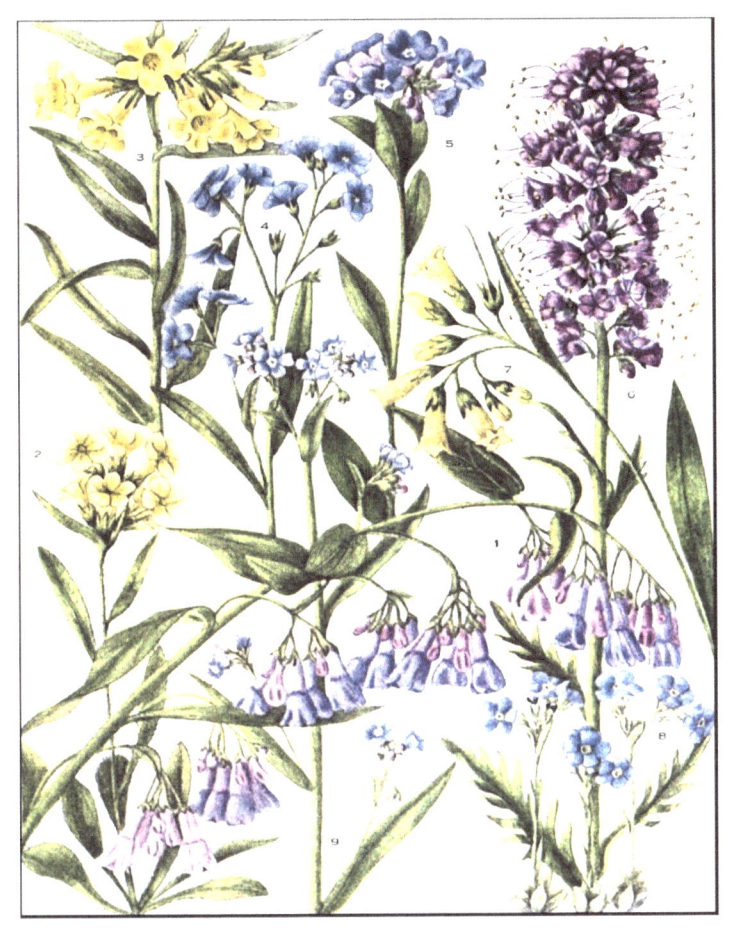
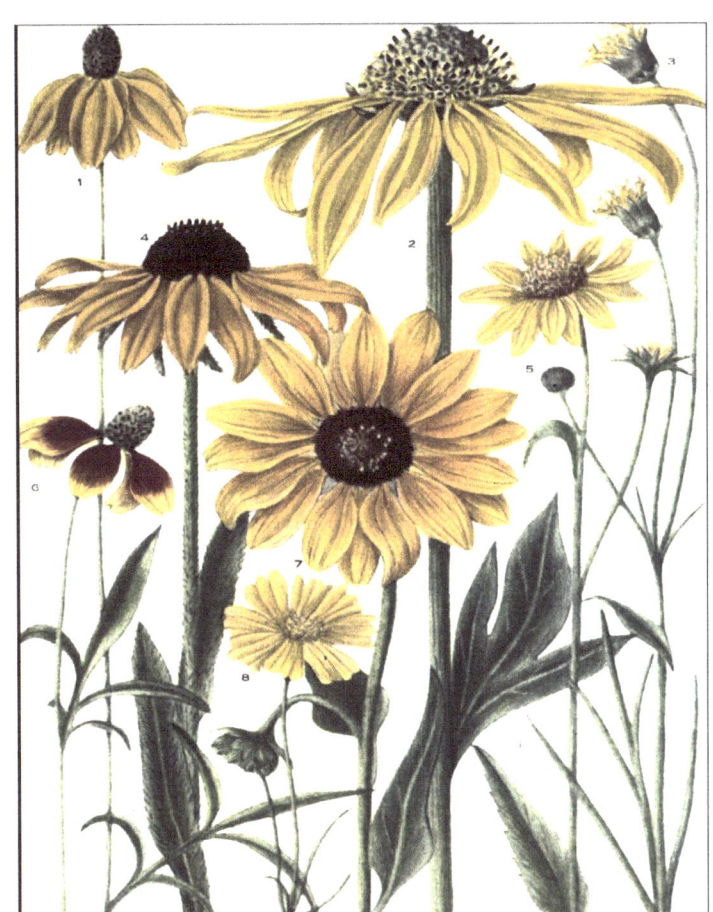
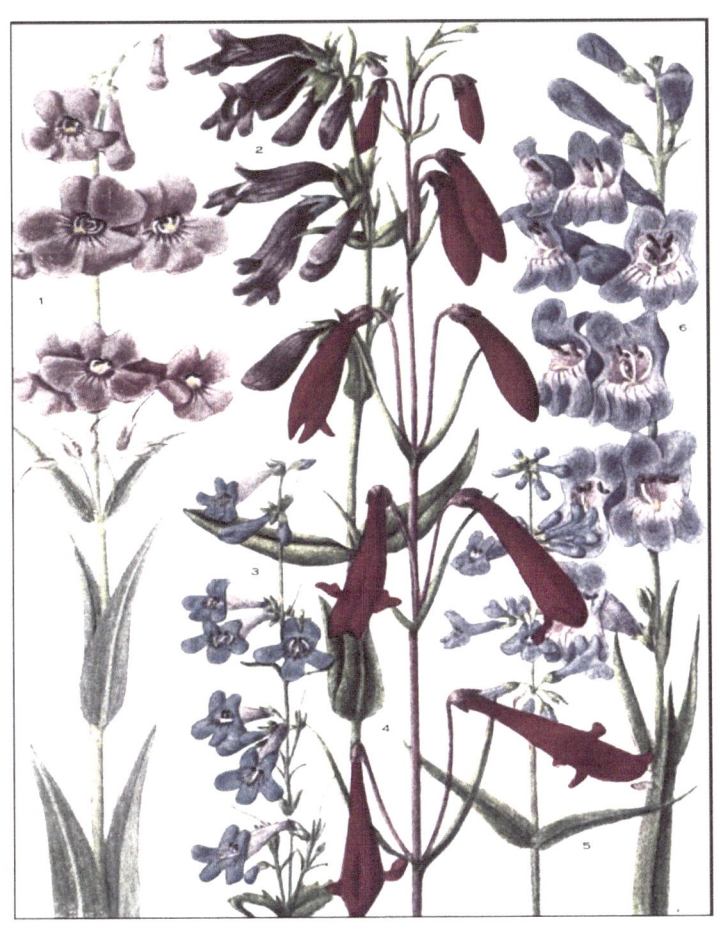
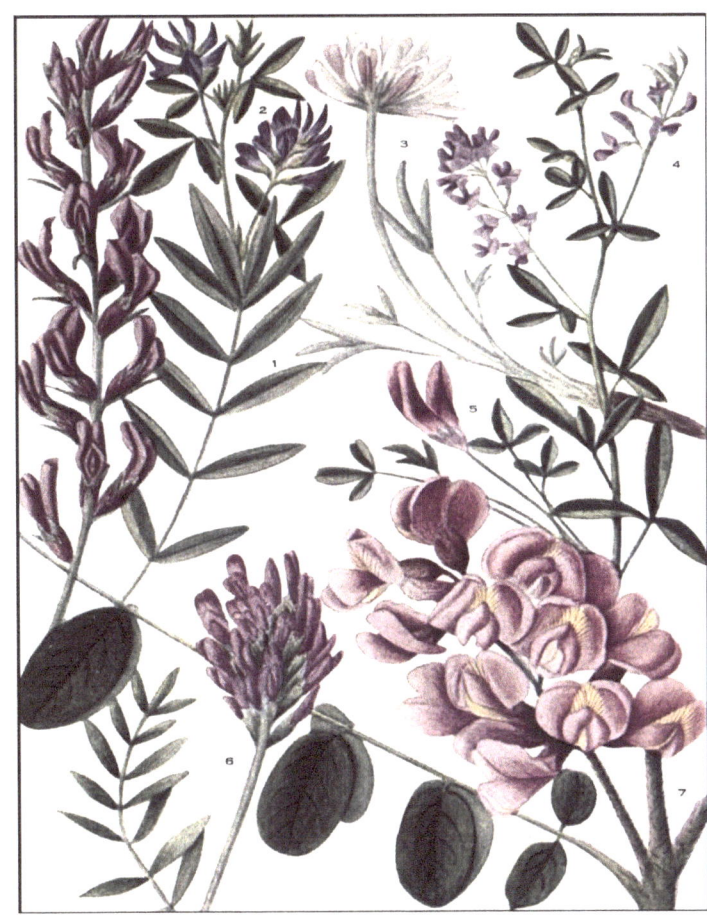

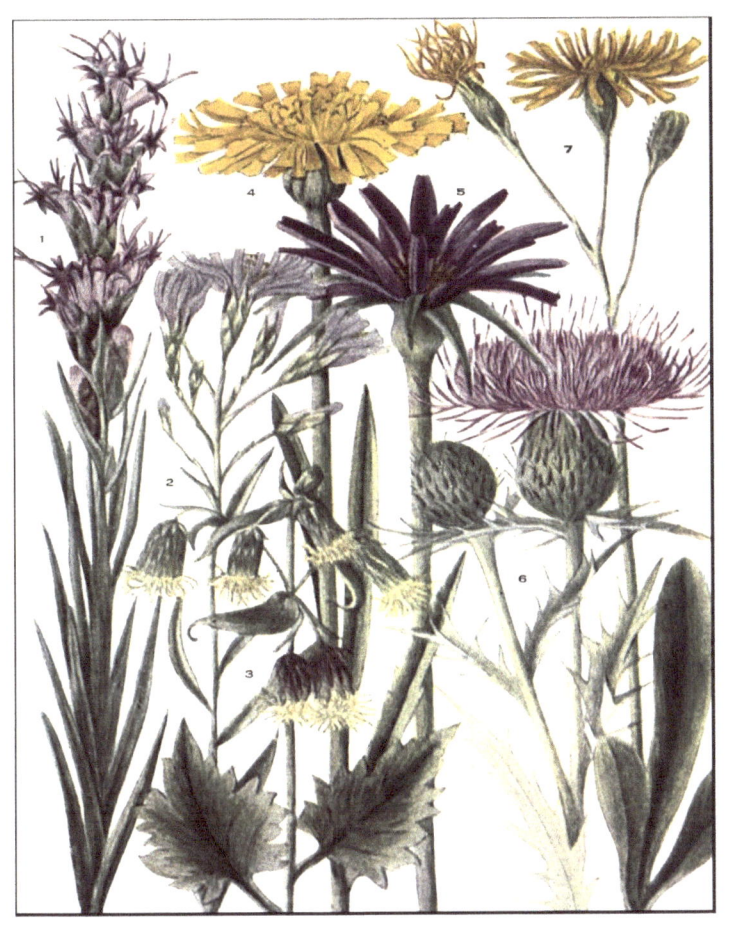
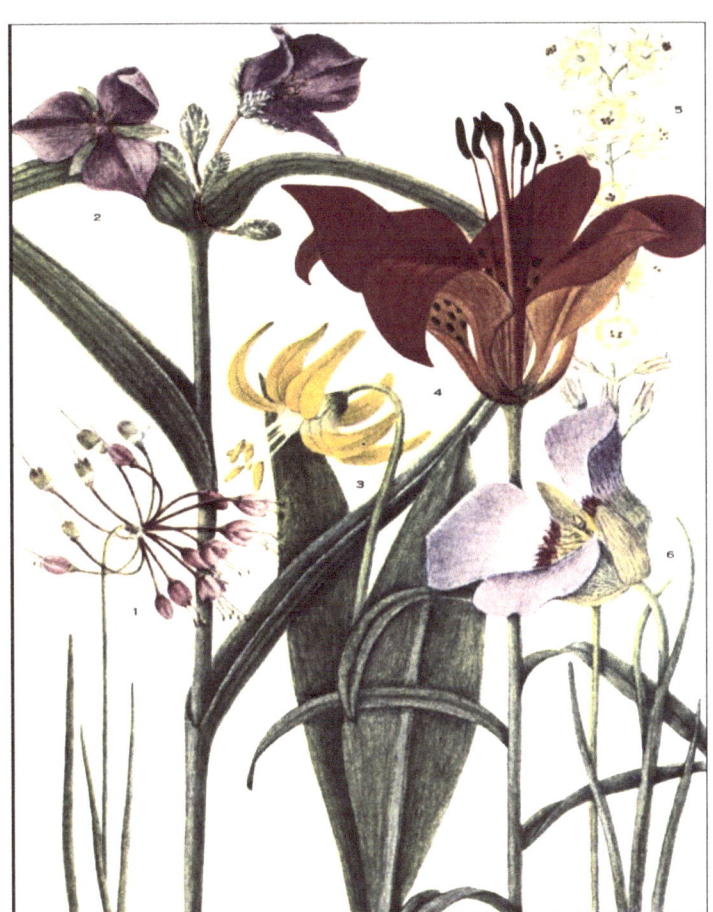
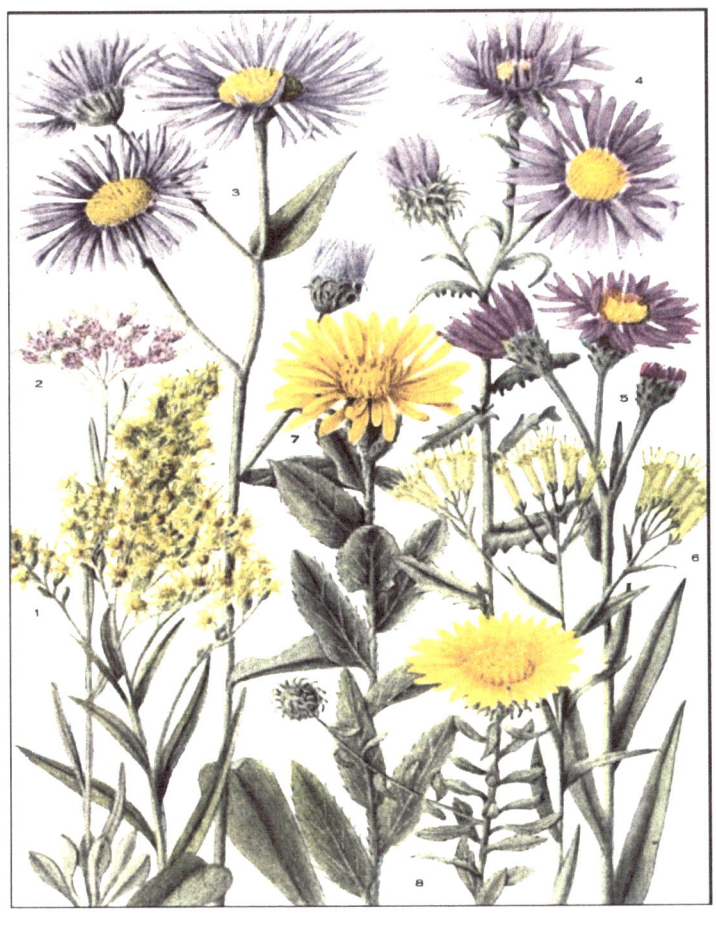
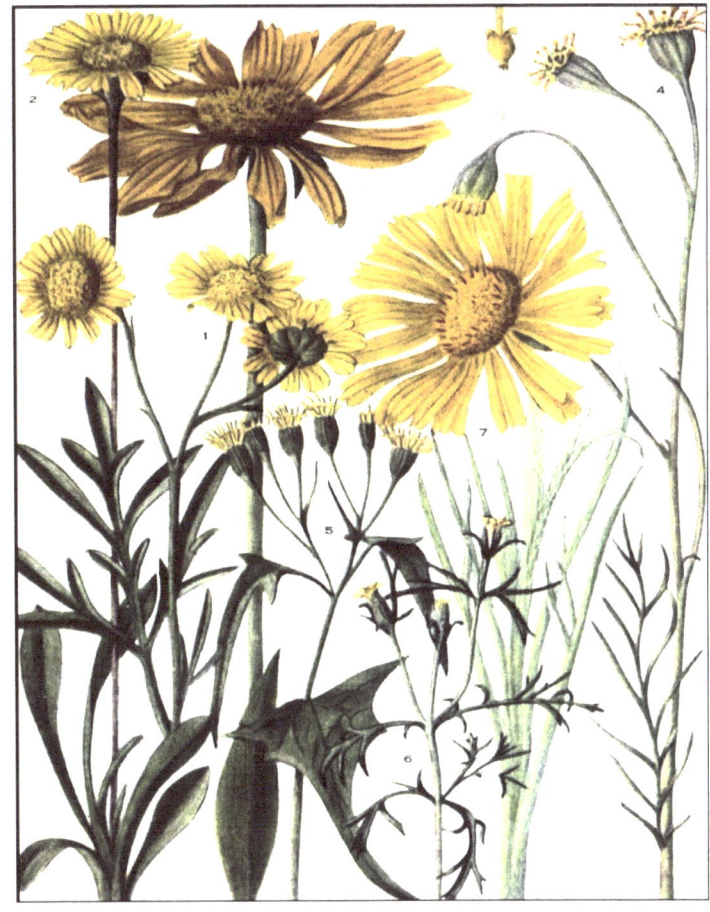

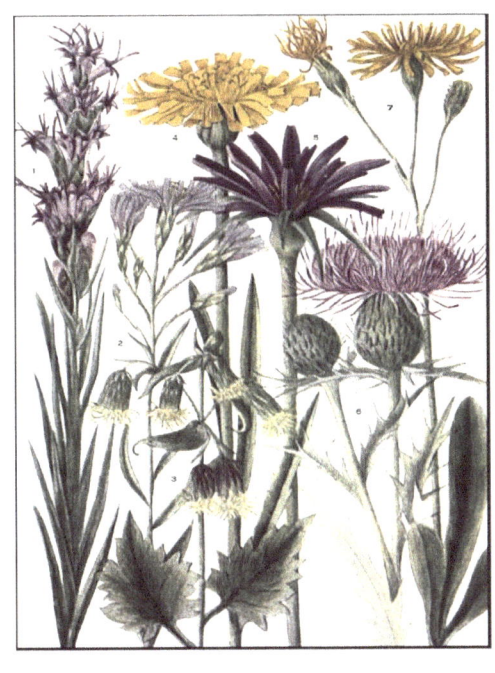
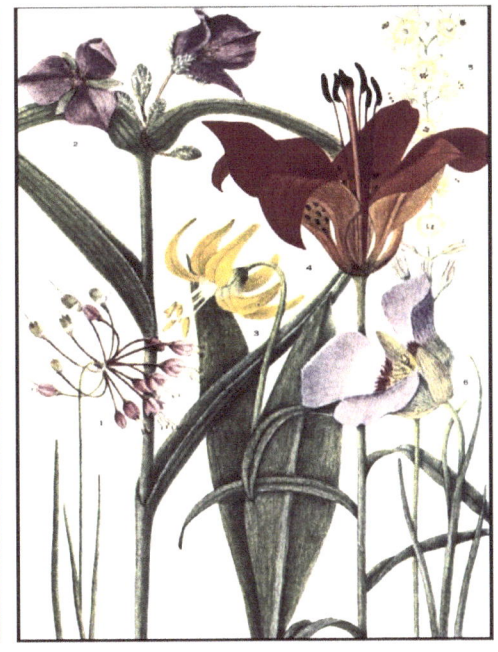
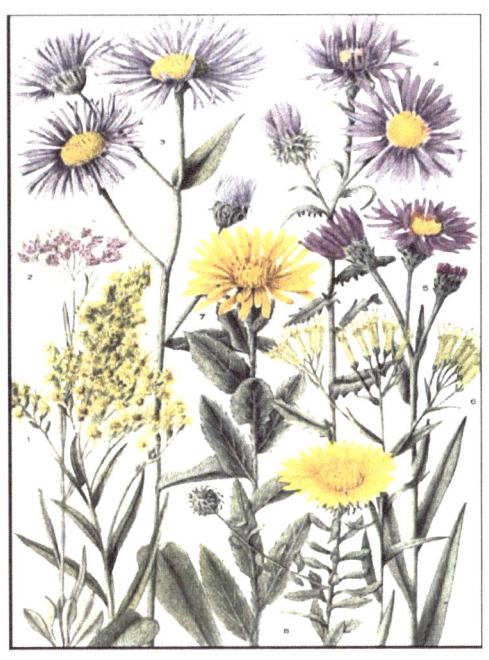
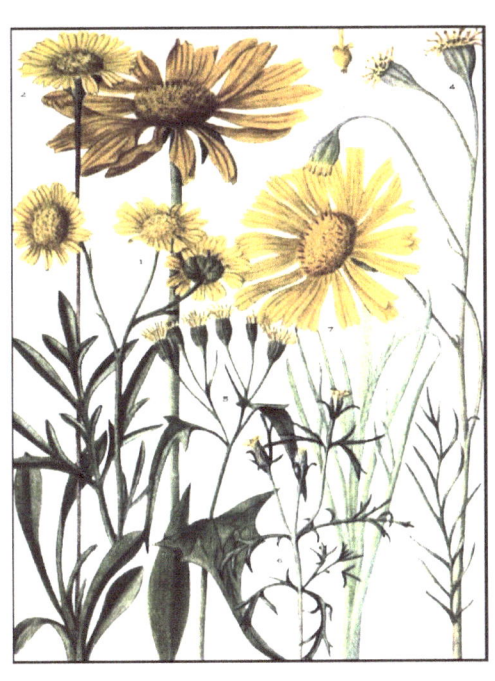
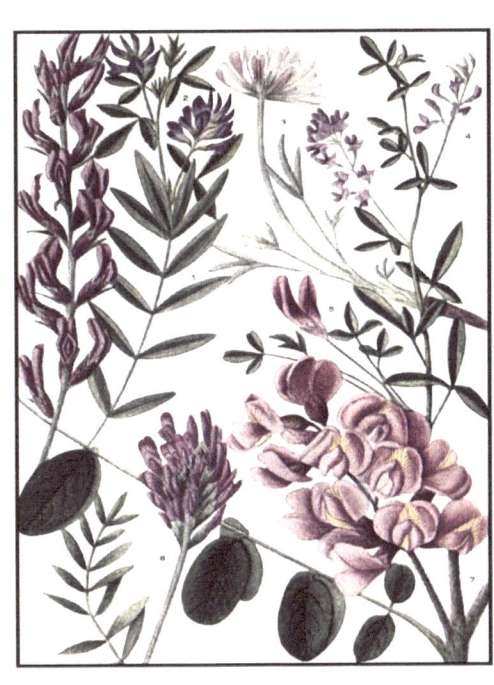
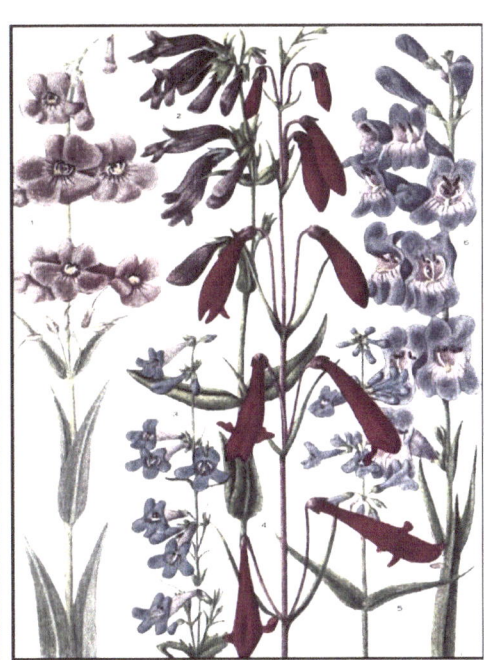
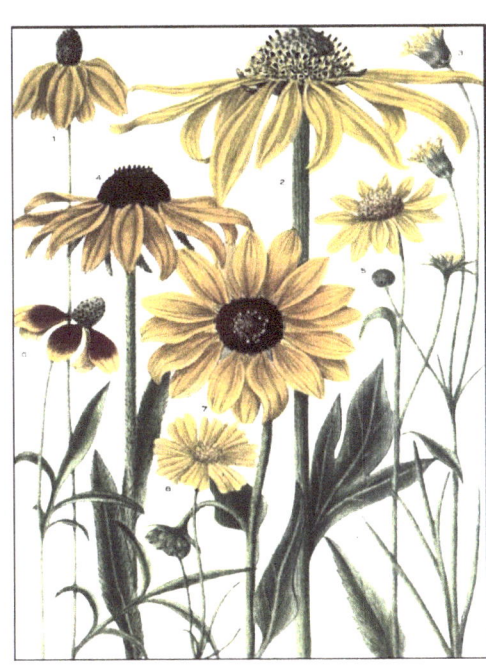
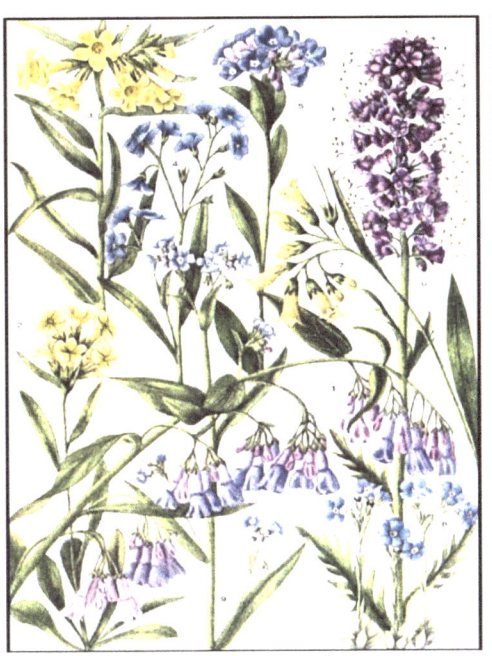
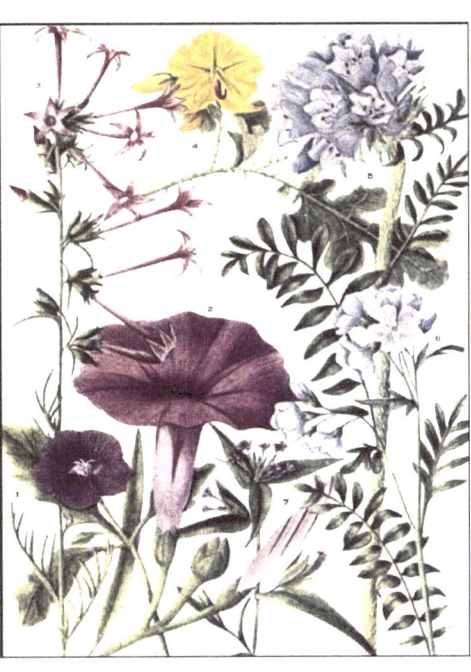

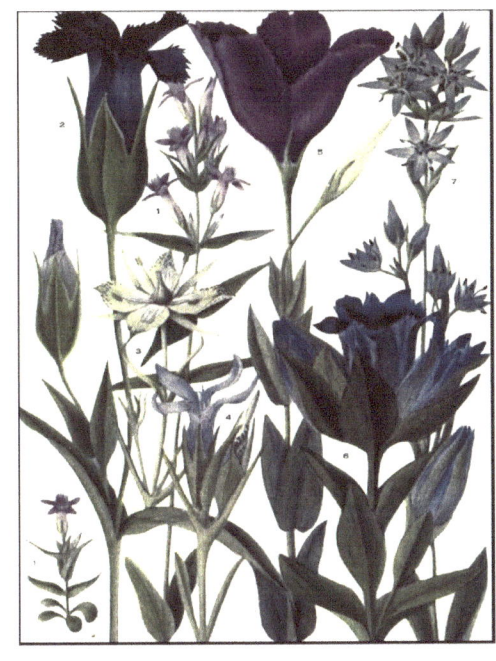
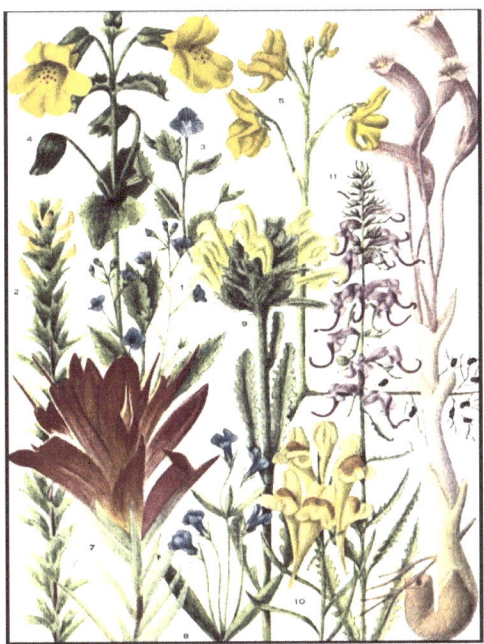
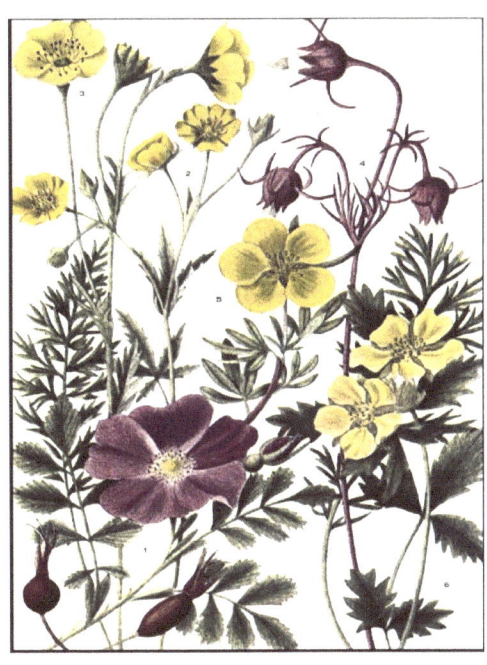
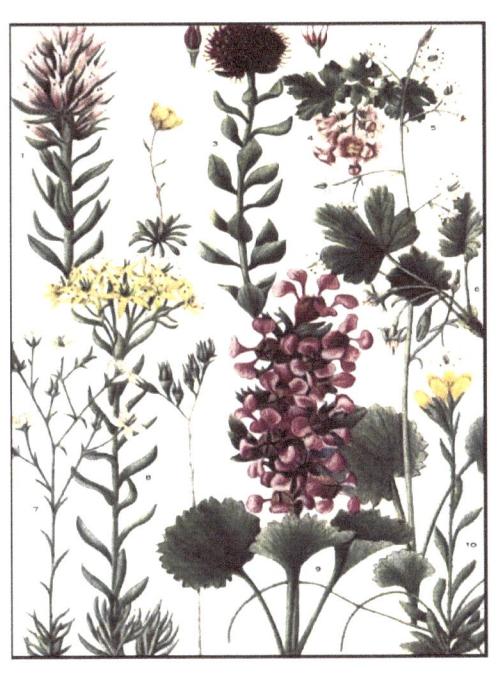
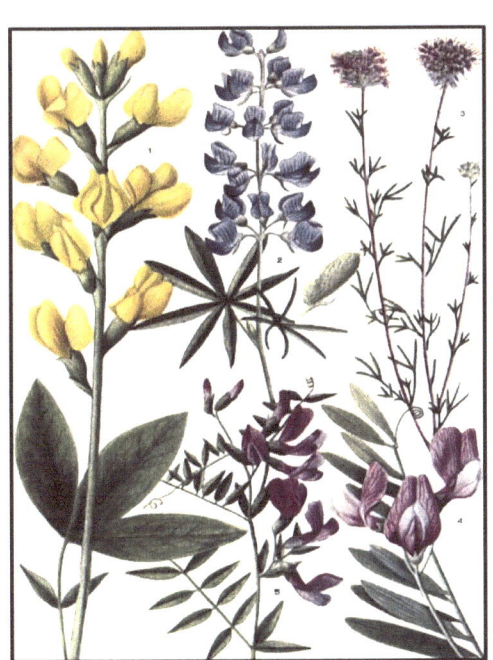
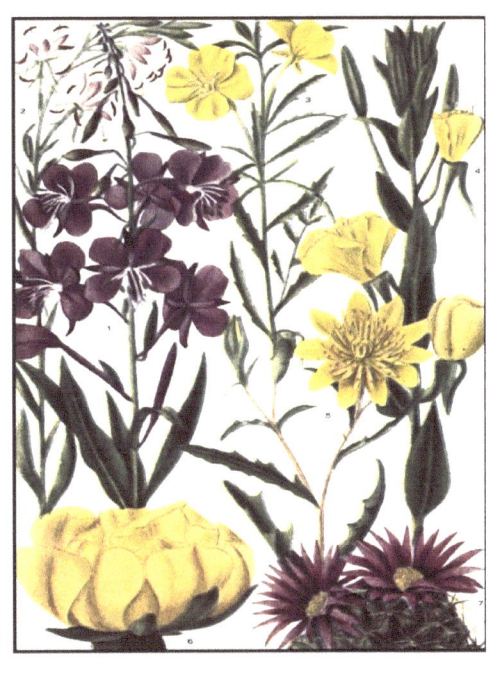
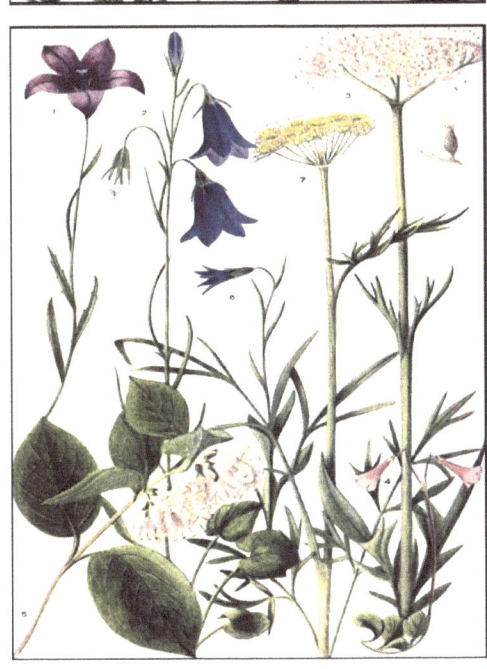
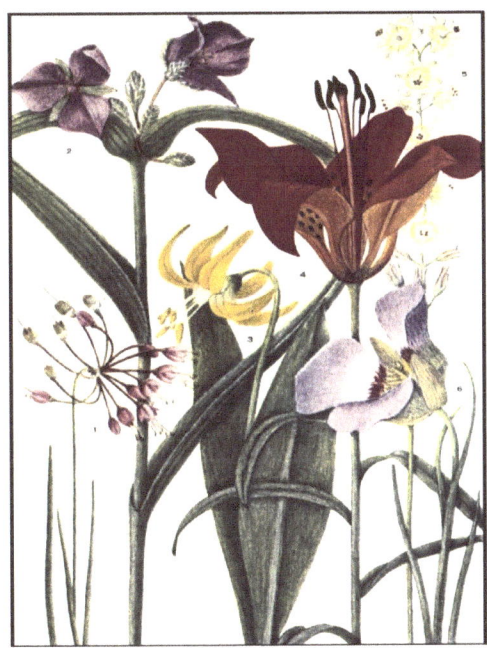
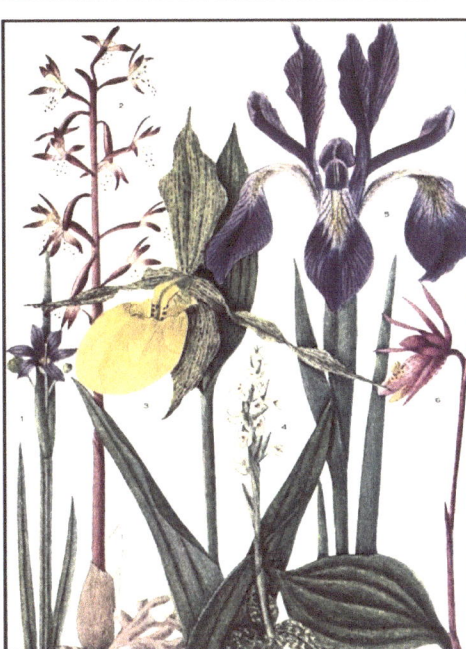

www.ingramcontent.com/pod-product-compliance
Lightning Source LLC
Chambersburg PA
CBHW041317180526
45172CB00004B/1138